IMAGES
of America

SEATTLE'S
MUSIC VENUES

THEY say that we are dead
 In Seattle

At nine o'clock we go to bed
 In Seattle

That there is no place to dine,
Or to have a quiet time,
And we don't drink beer or wine
 In Seattle

But, my boy, I've done the line
 In Seattle

Bet your life that I got mine
 In Seattle

All the girls were mighty fine,
And when it comes to drinking wine
That is where the dear ones shine
 In Seattle

Autos running to and fro
 In Seattle

To the City Park they all go
 In Seattle

Life you'll find is just a song,
Nights too short and days too long,
Boys and girls one merry throng
 In Seattle

IN SEATTLE

At the best hotel we dine
 In Seattle

Nothing goes with us but wine
 In Seattle

Our dear girlies looking prime,
Always ready for a time,
None on earth are just as fine,
 In Seattle

And the married ladies, too,
 In Seattle

To their husbands all are true
 In Seattle

With no other men they'll go;
Always talk and act just so;
Never naughty. Oh! No! No!
 In Seattle

And when the lights are burning red
 In Seattle

When you think they're all in bed
 In Seattle

All the sights I'd hate to tell,
But you'll find we're going well;
For a dead town this beats hell,
 In Seattle

"IN SEATTLE" POSTCARD. This is a 1910 tongue-in-cheek postcard about daily life in Seattle. Based on the skewed print of the words "In Seattle," it appears the company may have created this version of a postcard for several different cities in the United States. (Author's collection.)

ON THE COVER: THE EMERALD PALACE. Located between Seventh and Eighth Avenues and Olive Way, this venue originally opened as the Fox Theatre in April 1929. Later, it became more famously known as the Music Hall. (Courtesy Library of Congress, 040729.)

IMAGES
of America

SEATTLE'S
MUSIC VENUES

Jolie Dawn Bergman

ARCADIA
PUBLISHING

Published by Arcadia Publishing
Charleston, South Carolina

Printed in the United States of America

Library of Congress Control Number: 2012954889

For all general information, please contact Arcadia Publishing:
Telephone 843-853-2070
Fax 843-853-0044
E-mail sales@arcadiapublishing.com
For customer service and orders:
Toll-Free 1-888-313-2665

Visit us on the Internet at www.arcadiapublishing.com

This book is dedicated to everyone who has made Seattle a beautiful place to dance, sing, learn, and rejoice.

CONTENTS

ACKNOWLEDGMENTS

This book would not have been possible without the love and encouragement from my husband, Michael Timmons, my mother, Eileen Kilgren, and all my wonderful friends and family. I am indebted to the very kind and helpful people at the Seattle Public Library, Seattle Municipal Archives, Washington State Archives, and the University of Washington Special Collections Library. I especially thank the Museum of History and Industry, HistoryLink, Northwest African American Museum, Wing Luke Museum, Nordic Heritage Museum, and the Experience Music Project, as well as all the historical societies of Seattle for preserving our beautiful past with such care and dedication. To Kirk Allen, Michael Fairley and Fairlook Antiques, Peter Blecha, Kelly Lyles, Robert Stenehjem, Peggy Wendel, Paul Reilly, Kathi Ploeger, Janet Aviado, Jim Page, and the many others who went well out of their way to assist me in sharing their time, energy, and stories—I thank you, endlessly. Of course, a huge thanks goes to Arcadia Publishing for giving me this opportunity.

INTRODUCTION

Music has always played an important role in the Pacific Northwest. From the first community center in the 1860s to today's Folk Life Festival, these locations have housed cultural and creative significance for generations of Seattleites.

Seattle, although wrought with mud, conflict, and social upheaval in the beginning, was still determined to move forward as one of the most important cities on the West Coast. The once unknown community grew quickly, attracting laborers and their families, as well as businesses looking for a new start. With a fast-growing city built predominantly out of wood, fire became an increasing concern, and unfortunately that apprehension was met with reality when in 1889 the Great Seattle Fire destroyed a majority of the city center. Seattleites, not to be detoured by a total structural catastrophe, marched forward with a new city made of buildings that were more durable. The structures were either built directly on top of the ashes or land was moved around the remaining structures in a project that created the Denny Regrade.

By 1914, Seattle boasted the largest shoe factory, dry docks, and brewery on the Pacific Coast. It was also known for having the largest fisheries and lumbering interests in the country. By 1923, Seattle was recognized as being one of the healthiest cities in the United States and the second most literate while boasting a population over 300,000. This combination of business success, employment security, and a growing populace provided a haven for entertainment venues that advertised fire-safe theaters, clever comedy, and world-famous operas.

During the early part of the 20th century, Seattle also boasted a successful jazz scene. Military personnel, while active, were not permitted to attend these attractions. They were even given a map of where not to go when stationed in the area, as these venues of vice were full of booze, women, and dancing. Still, the music scene prevailed in such hot spots as the Black and Tan Club, the Spokane Club, Royal Esquire Club, Savoy Ballroom, and the Rocking Chair, a location often attended by Ray Charles. These businesses often turned a blind eye to racial differences, instead relaying on each other to help build successful enterprises for the community.

Neighborhood centers and clubs developed a stronghold in the area as waves of immigrants were calling Seattle their new home and trying to integrate with unfamiliar neighbors. For instance, the Nippon Kan hall in Seattle's International District was an entertainment and education center for many citizens. Japanese Nisei dances were held not only in this hall, but also the Olympic Hotel, Queen Anne Field House, and the Collins Field House. The Washington Hall, Swedish Club, Sons of Norway Hall, and Skandia Ballroom also brought the Nordic countries together in dance as well as community events so that neighbors could congregate to take care of each other in times of joy or need.

While the world propelled forward into the mid-20th century, Seattle became host to the World's Fair. This event was a fantastic opportunity to showcase the latest technological and cultural advancements of the generation. Seattle was ready for that spotlight, although it meant changes to the city. A significant proportion of the lower part of Queen Anne Hill neighborhood

was cleared out to make room for the event. Over 50 years later, this area is still host to some of the largest outdoor musical events on the West Coast.

Spanning the last 150 years, Seattle has been a musical hub for visionaries and risk takers. Many venues portrayed in this book have been locations where new ideas were hatched, couples met, the community came together, and creativity was inspired. In all, the music venues of Seattle have showcased growth, entertainment, understanding, drama, inspiration, comedy, and of course have brought people together through the universal language of music.

One

FROM COOKHOUSE TO OPERA SEATS

In the 1850s, as Seattle was forming, the Yesler Mill Cookhouse not only housed the jail, military headquarters, and hotel at times but also acted as the community auditorium for local and traveling shows. Over a relatively short period of time, larger establishments began to grow around the shack foundations of the city, such as Plummer's Hall, Yesler's Hall, and Yesler's Pavilion. By 1879, Squire's Opera House opened its doors as Seattle's first official theater.

As the population grew, so did the size and number of establishments. Venues became more elaborate and sophisticated, all the while more community centers and park pavilions expanded to accommodate the rise of residential neighborhoods. Just as quickly as the city was being built, new houses of entertainment were erected to welcome the millions of visitors to the Alaska–Yukon–Pacific Exposition in 1909 and the first Golden Potlatch festival in 1911. By the first quarter of the 20th century, Seattle was ready to showcase its booming entertainment scene.

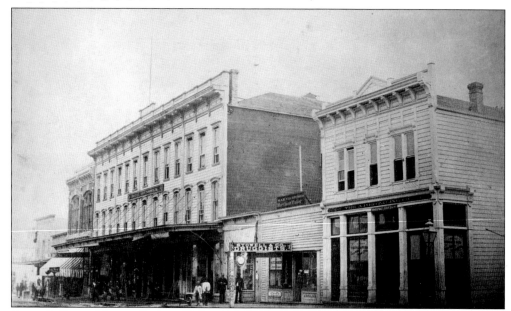

SQUIRE'S OPERA HOUSE. Built in 1876 and located on First Avenue between Washington Street and Main Street, Squire's Opera House (left) had two levels of seating to accommodate 584 people. By 1882, it had become the New Brunswick Hotel. The building burned in the fire of 1889. (Courtesy Seattle Public Library, shp_5072.)

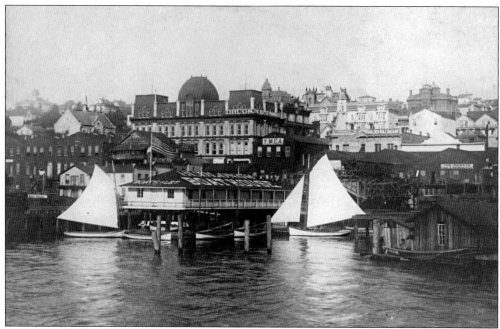

FRYE'S OPERA HOUSE. This photograph, taken from Seattle's waterfront in 1887, shows the beautiful domed opera house that once stood on Second Avenue between Madison Street and Columbia Street. Seattle's first organized brass band performed here and in January 1885 so did the notorious Langrishe Dramatic Company. (Courtesy Seattle Public Library, shp_5203.)

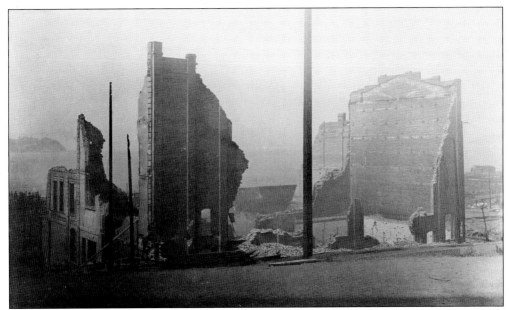

FRYE'S OPERA HOUSE POST FIRE. Very little of Seattle's finest opera house survived the fire of 1889. By the time this photograph was taken, men were employed to tear down what remained of the building. (Courtesy Seattle Public Library, shp_5056.)

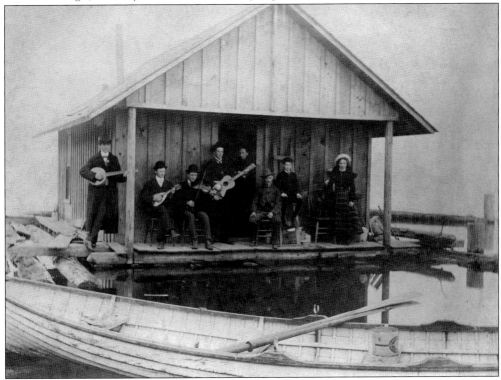

RAINIER BAND. Musical performances in Seattle were not reserved to public venues. This unique and touching 1902 photograph shows the Schahn family band on the porch of a Lake Washington boathouse at Rainier Beach. (Courtesy Seattle Municipal Archives, 66254.)

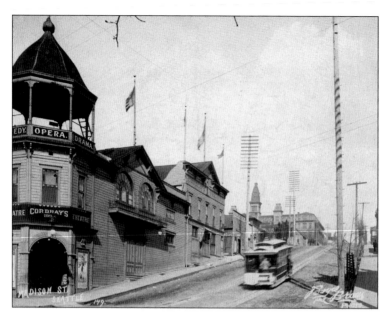

CORDRAY'S THEATER. Built in 1890 and located on the Northeast corner of Third Avenue and Madison Street, this theater was known as both the Madison Theater and Cordray's Theater until 1894. It was the Third Avenue Theater until 1908, when the building was razed. A skyscraper is now located on this lot. (Courtesy Seattle Public Library, shp_5231.)

THE ALASKA–YUKON–PACIFIC EXPOSITION MUSIC PAVILION. A crowd forms around the Music Pavilion in this 1909 image. The exposition was held on the undeveloped grounds of the University of Washington campus between June 1 and October 16, 1909. Musical acts from around the world performed here, including the Innes Orchestral Band. (Courtesy Seattle Public Library, shp_11994.)

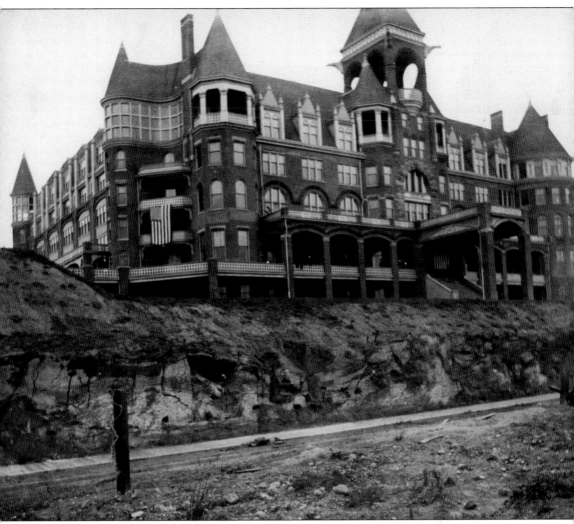

WASHINGTON HOTEL. Initiated in 1890 as the Denny Hotel, this building once stood on what is now the northeast corner of Second Avenue and Stewart Street. By 1893, the building was not entirely finished when a stock market panic swept the nation. Despite financial setbacks and standing as an incomplete building, events such as the Assembly Ball and other musical gatherings occurred here on a regular basis. (Courtesy Seattle Public Library, shp_14161.)

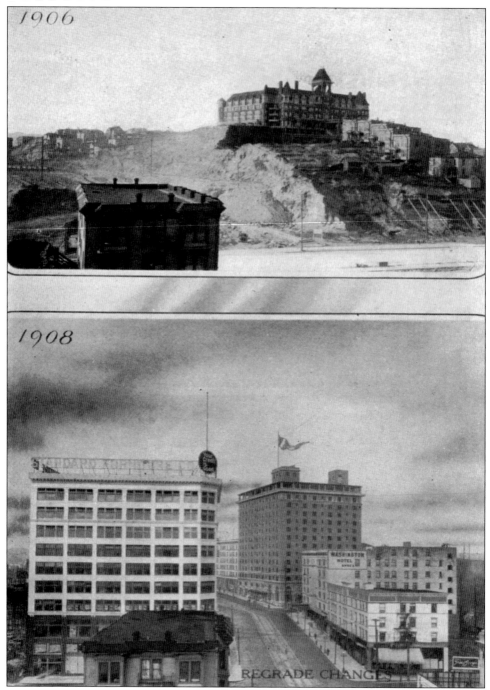

1906

1908

REGRADE CHANGES

NEW WASHINGTON HOTEL. The image above shows the Denny Hotel, amidst the Denny Regrade, three years after Pres. Theodore Roosevelt visited and praised the establishment. Despite the much-publicized acclaim, the building stood virtually empty for 10 years and was demolished in 1907. A new Washington Hotel Annex, seen in the image below, was built across the street. It became part of the Moore Theatre building and was later renamed the Moore Hotel. (Author's collection.)

VOLUNTEER PARK MUSIC PAVILION. This 1910 photograph shows Volunteer Park not long after the Olmsted Brothers helped design the park and music pavilion. Musical performances have occurred here since the Alaska–Yukon–Pacific Exposition of 1909. The park continues to thrive as a music venue to this day. (Courtesy Municipal Archives, 30465.)

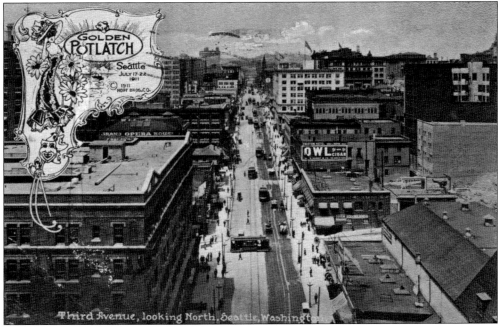

GRAND OPERA HOUSE. This is a bird's-eye view of Seattle in 1911 through a postcard advertisement for the first Golden Potlatch festival. The Grand Opera House (back left) was located at 217 Cherry Street. In 1900, John Cort opened the venue to seat 2,200 people. A late-night fire from the curtains in 1906 and another fire in 1917 simply became too much of a burden, and the building was gutted. The shell of the building survives today as a parking garage. (Author's collection.)

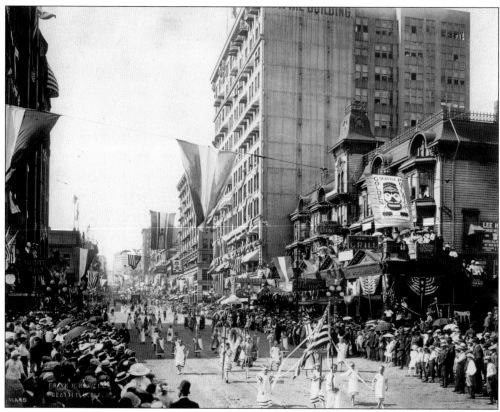

GOLDEN POTLATCH FESTIVAL. The first Golden Potlatch festival was held in Seattle on July 17, 1911, in honor of the 1897 arrival of the steamer *Portland*, hailed for bringing gold from Alaska. The festival was held over a five-day period, and it is estimated that nearly 300,000 people attended the citywide concerts and parades. The Golden Potlatch festival was celebrated annually until the beginning of World War I. It recommenced in 1934 but ended again because of World War II. (Photograph by Frank H. Nowell, courtesy Seattle Municipal Archives, 30953.)

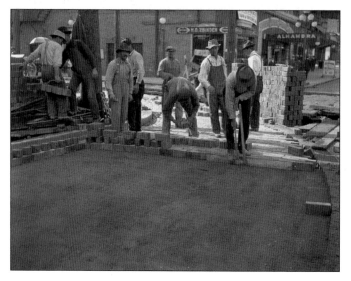

ALHAMBRA THEATRE. This 1913 photograph shows Seattle's downtown city streets being repaved. In the background is the Alhambra Theatre, located on the southwest corner of Pine Street and Fifth Avenue. The theater opened in July 1909, and over the years it housed the Wilkes Theatre, Best Apparel, and Nordstrom's. A rejuvenated Alhambra Cabaret Theater later opened at 1205 Jackson Street. (Courtesy Seattle Municipal Archives, 6506.)

FIRST AVENUE SALOON. The First Avenue and Yesler Street area of downtown Seattle has been known as a rough-and-tumble neighborhood, especially prior to the 1920s. This seedy section was high in vice where music, dancing, and gambling went hand in hand. Pictured here is a side entrance to one of the many drinking and gambling parlors in the area in 1914. (Courtesy Seattle Municipal Archives, 243.)

BALLARD FIELD HOUSE. This popular hall was located at Adams School in the Ballard neighborhood. In a 1914 image, Ballard youth demonstrate a dance (regarded as excellent exercise), one of the many activities held at this venue. (Courtesy Seattle Municipal Archives, 28816.)

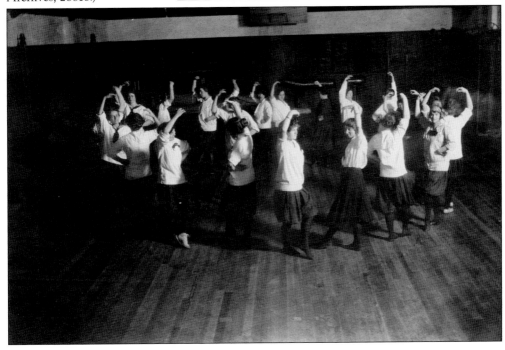

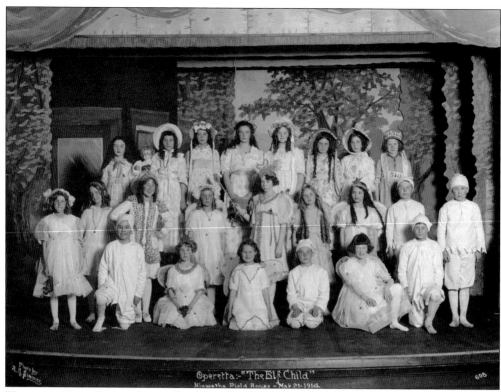

HIAWATHA FIELD HOUSE. Located in West Seattle, this recreation center is a community hub for entertainment. Designed by the Olmsted Brothers, the field house opened in 1911 and was one of the first public recreation buildings in the Northwest. Pictured here in March 1914 is the cast of a five-act play presented by the Junior Dramatic Club. (Photograph by A.G. Simmer, courtesy Seattle Municipal Archives, 29295.)

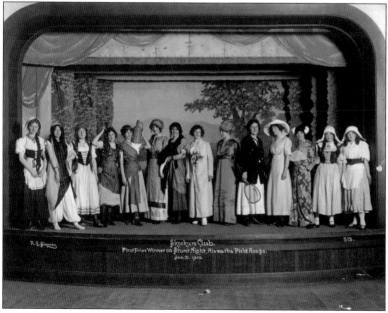

HIAWATHA FIELD HOUSE STUNT NIGHT. Seen here is the Skookum Club, one of many Seattle area clubs that performed at a January 1913 Stunt Night in the field house. The Skookum Club won first place that evening. Stunt Nights included dancing, singing, comedy sketches, and fashion reviews. (Courtesy Seattle Municipal Archives, 29290.)

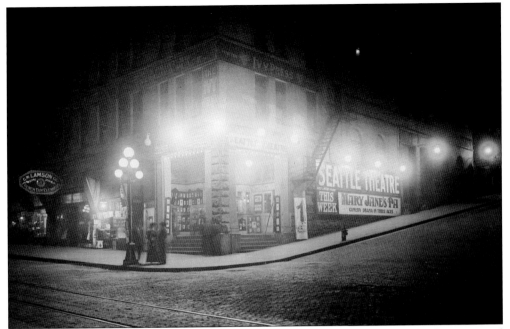

SEATTLE THEATRE. This theater was located on the northeast corner of (700) Third Avenue and Cherry Street. One particular night at this venue in January 1900, the performance of *Shenandoah* was so popular that people demanded the troupe return for one more evening. A *Seattle Times* advertisement announced the troupe's return and added, "Enough Is Said. Get Your Seats." The building was razed in 1915, and the Arctic Club building was erected in its place. (Courtesy Seattle Municipal Archives, 136.)

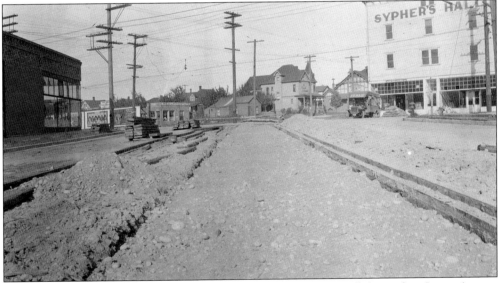

SYPHER'S HALL. This is a 1917 photograph of the large Sypher's Hall, located on Leary Avenue near Market Street in the Ballard neighborhood. Dances were held here on a regular basis, as were meetings, fundraisers, and community concerts. On one particular December 1902 evening, the Sterling Club sponsored a masquerade dance in this venue, where prizes were given to the most "romantically-dressed couple." (Courtesy Seattle Municipal Archives, 12468.)

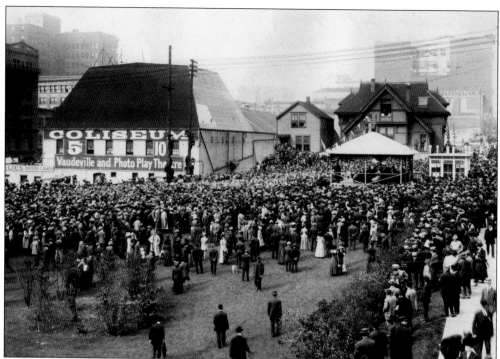

OLD COLISEUM. Pres. William Howard Taft is speaking to a growing crowd next to the old Coliseum Theatre. For 10¢, patrons were entertained by popular vaudeville acts in this venue, such as the musically talented Minne Middleton, magicians, comedians, and her African lions. (Courtesy Washington State Archives, AR-07809001-ph005212.)

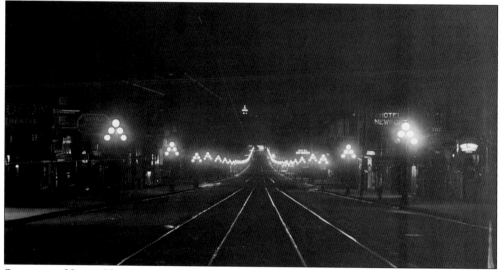

SEATTLE AT NIGHT. Here is a peaceful night scene of downtown Seattle in 1914 near (1413) Second Avenue and Pike Street with the Odeon Theatre on the left. This venue placed several want ads with the *Seattle Times* over the years while in business. One 1908 ad claimed Odeon Theatre was looking for "a young attractive lady, weighing not over 110 lbs." Another ad was looking for amateurs to perform and win cash prizes, while others were pleas to return a lady's lost fur stole. (Courtesy Seattle Municipal Archives, 188.)

Two

Vaudeville, Cabaret, and Variety Shows

The city of Seattle was certainly coming into its own by the early 1900s. Changing roadwork, electricity, and different entertainment venue types dominated the quickly changing landscape. Aggressive, competing vaudeville venues were growing in number and did not wane until moving picture shows and talkies dazzled the public's attention to the screen. Until then, however, music acts in all forms, be them risqué or clean, were advertised throughout the city. By the 1930s, most vaudeville halls were either turned into movie houses or closed for good. Highbrow venues continued to flourish, though, as did dinner and dance establishments.

Entertainment venues during this time period included the Lois Theater, the Paramount Theatre, The Showbox Theater, Luck Nigh Chinese Musical Club, the American Theater and Pan-American Theatre, the Oak Theatre, Circuit Theater, Olympic Theatre, and many others. The following chapter details just some of those venues, and the images relayed not only showcase the venues but also provide a very telling atmosphere of the era.

Rathskeller Orchestra and Cabaret

WILL A. PRIOR, MUSICAL DIRECTOR
Week commencing December 30, 1912.

6:15 to 8:15

1. Overture, "Ruy Blas"..................Mendelssohn
2. Miss Beverly Ashton—Rag Time Favorite.
3. SerenadeDrdla
4. Lillian Holmes—Popular Songs
5. CoquetteArensky
6. Blamphin and Hehr
7. Lune de Miel (Waltz)..............Waldteufel
8. Miss Irene May—Popular Selections
9. Selection, "Dream City and the Magic Knight" ..Herbert
10. Miss Beverly Ashton—Rag Time Favorite
11. Hungarian FantasieTobani
12. Lillian Holmes—Popular Songs
13. Chanson TristeTschaikowsky
14. Blamphin and Hehr
15. Miss Irene May—Popular Selections
16. "The Detective"Rosey

9:30 to 12:30

1. Selection, "The Quaker Girl"..............Monckte
2. Miss Beverly Ashton—Rag Time Favorite
3. Lillian Holmes—Popular Songs
4. Intermezzo from "The Jewels of the Madonna" ..Wolf-Ferra
5. Blamphin and Hehr
6. Miss Irene May—Popular Selections.
7. "Heather Bloom"Kingsbu
8. Miss Beverly Ashton—Rag Time Favorite
9. Lillian Holmes—Popular Songs
10. Blamphin and Hehr
11. Selection, "The Tattooed Man"..............Herbe
12. Miss Irene May—Popular Selections
13. Miss Beverly Ashton—Rag Time Favorite
14. Lillian Holmes—Popular Songs
15. "Peer Gynt Suite"Grie
16. Blamphin and Hehr
17. Miss Irene May—Popular Selections
18. Hoch HabsburgKr

RATHSKELLER ORCHESTRA AND CABARET. Pictured here is a program advertisement for one of the Rathskeller Orchestra performances. A popular place for a night on the town or after-theater dinner, the Rathskeller was a place to be and to be seen. The Rathskeller was located at 1110 Second Avenue near Seneca Street. The first floor housed the Rathskeller Buffet, while the second floor housed the café. (Author's collection.)

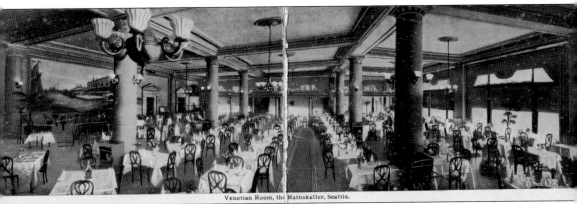

Venetian Room, the Rathskeller, Seattle.

RATHSKELLER VENETIAN ROOM. This is the inside of the same program advertisement for a December 30, 1912, performance at the Rathskeller. A *Seattle Times* article described one early 20th-century New Year's Eve party here as "everywhere everybody had the time of his or her life, and if anyone got up this morning with a dark brown taste and a bad head, nobody cared." (Author's collection.)

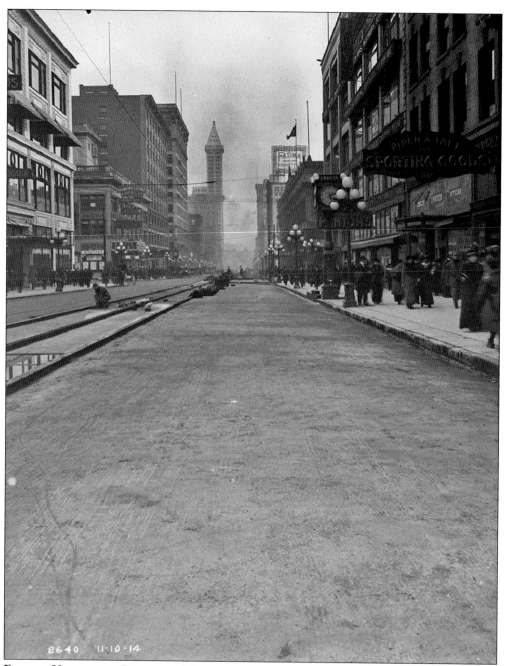

EMPRESS VAUDEVILLE. Repaving of the city streets did not detract customers from frequenting entertainment venues. This vaudeville house (left background) was located at 1016 1/2 Second Avenue near Madison Street. The venue was nestled near other popular vaudeville and musical establishments, such as Pantages and the Rathskeller. (Courtesy Seattle Municipal Archives, 43364.)

Majestic Theatre. The Washington governor is part of a group speaking to a crowd of Ballard residents on the opening day of the municipal street railway on January 27, 1918. Pictured in the background to the right is the Majestic Theatre. It opened as a vaudeville hall, and by 1923 it began showing movies. (Courtesy Seattle Municipal Archives, 12496.)

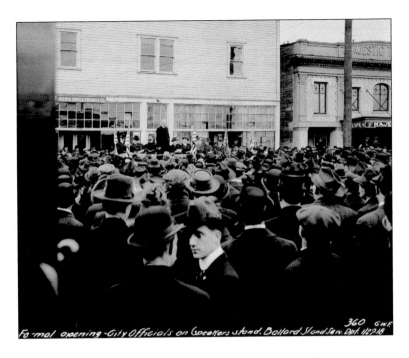

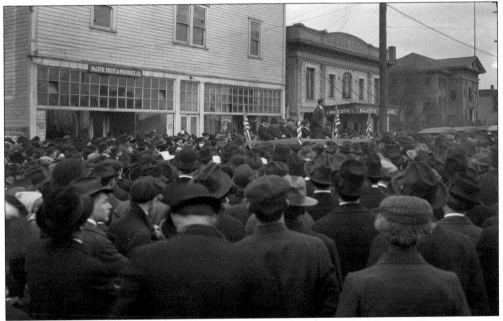

Majestic Theatre City Crowd. Looking east on Market Street, the Majestic Theatre sits near Twentieth Avenue and Market Street. Although its beginnings were in vaudeville, it has become one of the longest-running movie theaters on the Pacific Coast and is still a popular location to this day. (Courtesy Seattle Municipal Archives, 12500.)

PALACE HIPPODROME. This 1920 photograph of 1022 Second Avenue, situated near Spring Street, shows the Palace Hippodrome or the "Palace Hip," as it was commonly called. This was a very popular place to see showgirls, musical acts, and comedy. (Courtesy Seattle Municipal Archives, 12822.)

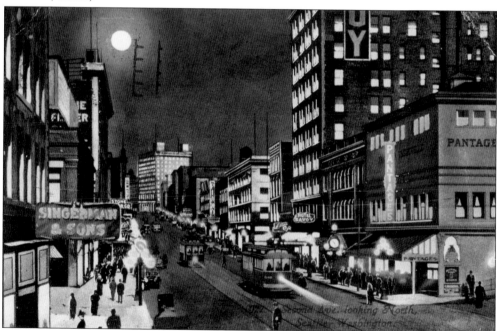

PANTAGES THEATRE NIGHT SCENE. This 1912 painted-postcard night scene of Second Avenue in Seattle shows one of the first Pantages Theatres (right). Located on the northeast corner of Second Avenue and Seneca Street, this theater was built by the earnings from Alexander Pantages's first Seattle business venture, the Crystal Theater. (Author's collection.)

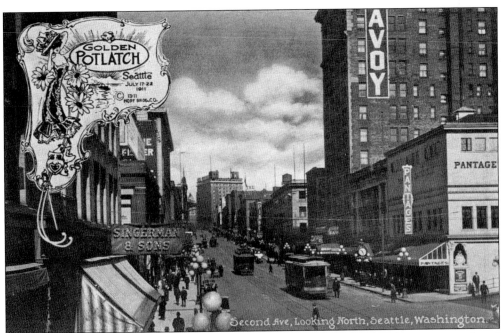

PANTAGES THEATRE DAY SCENE. This is a postcard of the same street scene, but not painted, and was used to advertise Seattle's first Potlatch festival. This Pantages Theatre was built in 1904. Alexander Pantages charged an average 10¢ for several hours of entertainment, and he was famous for knowing what the audience wanted. The business venture quickly grew successful, and by 1909 he owned mansions in Seattle and Los Angeles. (Author's collection.)

PANTAGES THEATRE. Pictured here are a street revision and a close-up view of the theater. Despite his business success, it is believed that Alexander Pantages was illiterate. Originally from Greece, Alexander arrived in Seattle in 1902, determined to succeed. And succeed he did, eventually owning several theaters along the Pacific Coast. This particular theater was remodeled in 1907 to accommodate growing crowds. (Courtesy Seattle Municipal Archives, 292.)

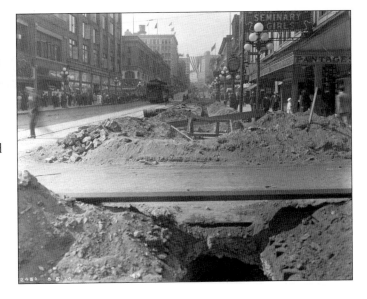

27

NEW PANTAGES THEATRE. Seattle's second Pantages Theatre, pictured here, was built in 1911 and located at Third Avenue and University Street. A considerably larger structure, Pantages worked closely with architect B. Marcus Priteca to develop his signature "Pantages Greek" building features. (Courtesy Seattle Municipal Archives, 38198.)

PANTAGES VAUDEVILLE AND PICTURES. By 1925, Alexander Pantages attempted to join the moving picture craze, turning his vaudeville-only establishments into joint live performance and motion picture ventures. Unfortunately, this business decision was not as successful for the Pantages Theatre chain. (Courtesy Seattle Municipal Archives, 38197.)

PANTAGES FROM THE STREET. By the 1930s, Pantages suffered several financial and personal calamities. Romantic scandals and poor business investments quickly turned this wealthy entrepreneur into a nearly forgotten figure in the entertainment world. (Courtesy Seattle Municipal Archives, 3129.)

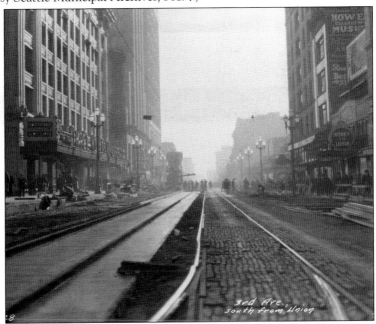

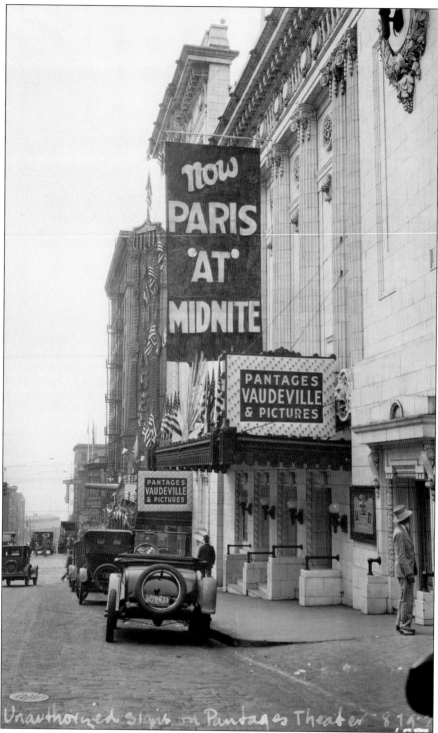

Unauthorized signs on Pantages Theater 8-19

PANTAGES GREEK. Alexander Pantages passed away in 1936. His Third Avenue and University Street theater carried on for a short while under new management as the Palomar, the Mayfair, and the Rex. The building was razed in 1965. (Courtesy Seattle Municipal Archives, 38193.)

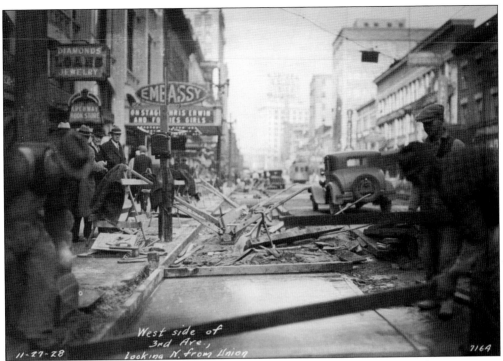

EMBASSY THEATER. This theater, photographed in 1928 amidst never-ending road construction, was located between Second and Third Avenues on Union Street. The building later became a theater for projected pornography and today is the home of the Triple Door theater, where patrons can see world-famous band performances and burlesque shows. (Courtesy Seattle Municipal Archives, 3121.)

GEM THEATER.
This theater
(right) was
located on the
corner of (115)
Second Avenue
South and Yesler
Street. Although
it originated as a
live entertainment
venue, by 1923
it too was
also showing
movies. (Courtesy
Seattle Municipal
Archives, 5981.)

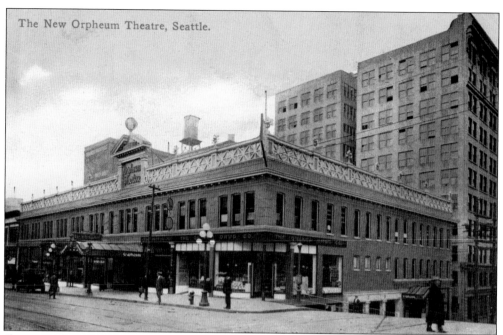

The New Orpheum Theatre, Seattle.

ORPHEUM THEATRE. Although advertised as "new" in this postcard, this venue was one of the first Orpheum venues in Seattle, located on the southwest corner of (917) Third Avenue and Madison Street. An even newer Orpheum was built later at a different location. In October 1915, Harry Houdini made his first performance in Seattle at this theater, showcasing his famous East Indian needle trick and escaping from a water torture cell. Ticket costs ranged from 10¢ to 50¢. (Author's collection.)

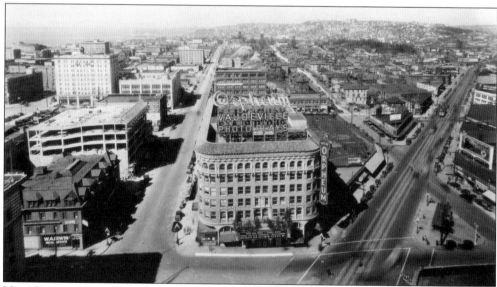

NEW ORPHEUM THEATRE. This latest Orpheum complex was built on the corner of Fifth Avenue and Westlake Avenue. It opened in 1927 and, for a short time, was one of the largest venues for vaudeville and movies in the Pacific Northwest. The Paramount Theatre opened six months later and surpassed the Orpheum in total seating. This building was razed in 1967. (Courtesy Seattle Municipal Archives, 9332.)

Three

ARMORIES, CLUBS, AND COMPANY GATHERINGS

As a significant port city and military hub, Seattle has played an important role in national security. As the world moved away from immigration waves and into the World War eras, Seattle was equipped to provide support for troops and their families as well as be a social staple for immigrants by way of community clubs, halls with military balls, and employee gatherings. These venues became a crucial way for people to connect and build their communities, foster traditions of their heritage, and grow together as a city. Some of those venues include the Aqua Barn, North View Dance Hall, Palladium, Polish Hall, Latvian Hall, Mountaineer's Club, and the Greenlake Field House. Many of the venues relayed here still play a significant role in Seattle today.

As Buddy Catlett described the area at the time, "The Army, the war, the shipyards, and Fort Lewis brought the culture up here. That's why you had so many musicians that could play, we're fortunate."

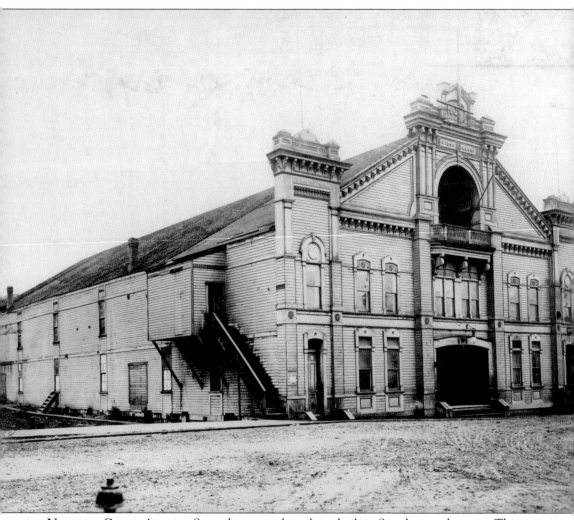

NATIONAL GUARD ARMORY. Several armories have been built in Seattle over the years. This one was located on the southwest corner of Fourth Avenue and Union Street. It was constructed in 1888 and demolished around 1909. An impressive castle-looking armory was later built near Seattle's waterfront. Finally, a new, more modern armory was built in lower Queen Anne, which later for a time became known as the Seattle Center's Food Circus. (Courtesy Seattle Public Library, shp_15227.)

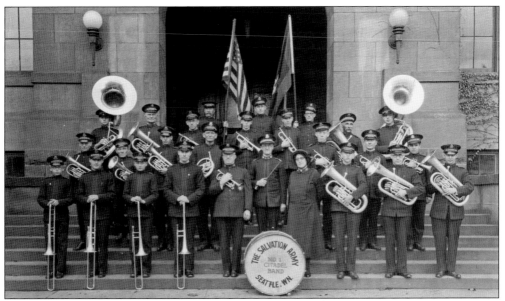

SALVATION ARMY BAND. This is a c. 1927 photograph of the No. 1 Citadel Band of the Salvation Army. The Salvation Army began in Seattle thanks in part to Alfred and Lizzie Harris, who arrived in 1887 with $20 and was given a little space to begin their community efforts in the basement of a local saloon. The Salvation Army has continued to provide Seattle-area residents with support ever since. (Courtesy Seattle Municipal Archives, 7408.)

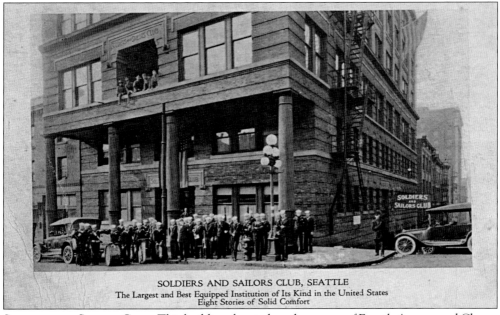

SOLDIERS AND SAILORS CLUB, SEATTLE
The Largest and Best Equipped Institution of Its Kind in the United States
Eight Stories of Solid Comfort

SOLDIERS AND SAILORS CLUB. This building, located on the corner of Fourth Avenue and Cherry Street, was previously the Seattle Athletic Club. It became the Soldiers and Sailors Club in November 1917 thanks to the efforts of the community, which donated funding and materials to transform the building into a state-of-the-art entertainment and sleeping-quarters establishment for soldiers. As a 1917 *Seattle Times* article stated, "Seattle is too patriotic and too hospitable to permit the men in Uncle Sam's uniform to suffer for a place to sleep." (Author's collection.)

SEATTLE FIRE DEPARTMENT. The Seattle Fire Department Orchestra was originally organized for the entertainment and relaxation of firemen but quickly grew in popularity for all Seattleites. It performed throughout the city for charities, balls, and all-over entertainment. This orchestra had its first radio performance broadcast on station KFOA on January 10, 1925. (Courtesy Seattle Municipal Archives, 64768.)

EAGLES HALL. This photograph from around August 1926 shows the building that is still located on the southwest corner of Seventh Avenue and Pine Street. The establishment was decorated to help welcome over 12,000 enlisted Navy soldiers for the annual Fleet Week. Elaborate expositions, dances, speeches, and parades occurred throughout the city for the event. Dances for the fleet officers were held in the building. The Eagles Hall now houses ACT (A Contemporary Theater). (Courtesy Seattle Municipal Archives, 2543.)

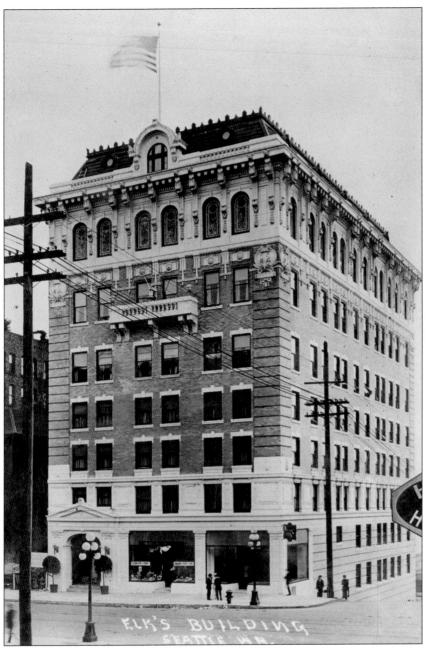

ELKS BUILDING. Completed by 1913 and located at 1017 Fourth Avenue, this building was constructed to handsomely accommodate Elks members and was host to many community events and dances. Nine stories high with living quarters, bowling alleys, a Turkish bath, and a swimming pool, the building was designated as one of the best Elks establishments in the West. The Elks often hosted minstrel extravagance events during Christmas. Although geared towards children in need, the extravaganza was available to all ages and was an attraction for thousands. One New Year's Eve in 1925, the ballroom of the Elks Club was decorated in Parisian scenes, including a Moulin Rouge replica. A *Seattle Times* article reported, "High frolic was held in the Elks Club." (Author's collection.)

Seattles' Original . . .

OLD TIME DANCE
(WHERE ALL SEATTLE MEETS FOR A GOOD TIME)
. . . IN THE . . .

SENATOR AUDITORIUM
SEVENTH AND UNION
•

REMEMBER EVERY

WEDNESDAY NIGHT AT NINE
WITH

BOB WHEELER'S
OLDTIMERS

SENATOR AUDITORIUM. This is an advertisement for a weekly dance held in the Senator Auditorium, a part of the Eagles Hall. Bob Wheeler performed his considerable musical talents in various venues, including regular appearances on radio broadcasts during the 1930s. (Author's collection.)

THE TALK OF THE TOWN . . .

BILL WINDER'S SENATORS
IN THE
SENATOR AUDITORIUM
SEVENTH AND UNION

★

EVERY
SATURDAY NIGHT AT NINE

I'LL BE LOOKING FOR YOU.
Bill.

SENATOR (EAGLES) AUDITORIUM. Pictured on the opposite side of the same advertisement is a weekly dance hosted by Bill Winder's Senators. Winder, who performed in many places and for many different events throughout the city, also offered 10 one-hour, $5 lessons in his studio on how to play jazz piano. (Author's collection.)

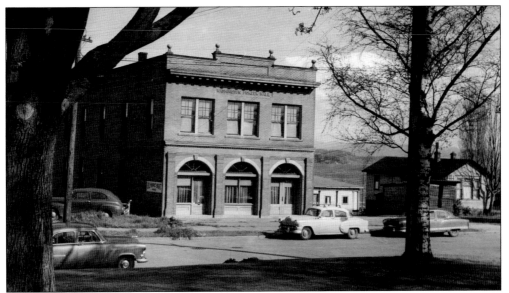

WASHINGTON PIONEER CLUB. Located at 1642 Forty-third Avenue, this hall was built in 1910 because of a financial donation from Sarah Loretta Denny on land of Madison Park founder Judge John J. McGilvra. The establishment was run by the Pioneer Association of the State of Washington and played host to many entertainment events and meetings for the pioneers of Washington State. This structure is now a museum. (Courtesy Washington State Archives, AR-07809001-ph002133.)

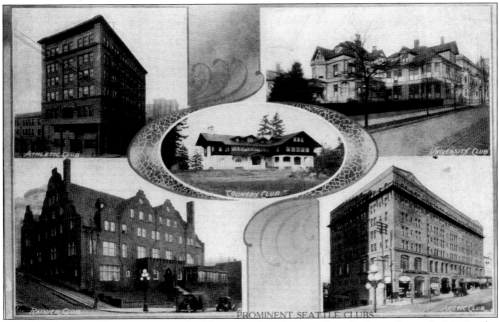

SEATTLE CLUBS. This is a postcard of five popular clubs in Seattle from the early 1900s: the Athletic Club (upper left), which later became the Soldiers and Sailors Club; the University Club (upper right); the Country Club (center); the Rainier Club (lower left); and the Arctic Club (lower right). The Rainier Club at 820 Fourth Avenue still exists, as does the University Club at Madison Street and Boren Avenue. (Author's collection.)

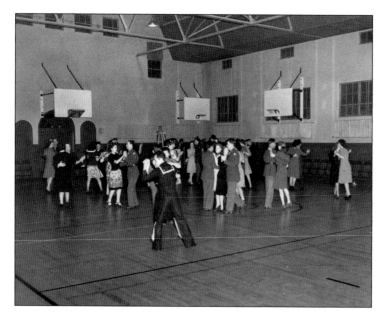

USO Dance. USO dances were a popular event in Seattle, especially during the World War II era. Dances were hosted in clubs, halls, and, as seen here, gymnasiums. (Courtesy Seattle Municipal Archives, 31070.)

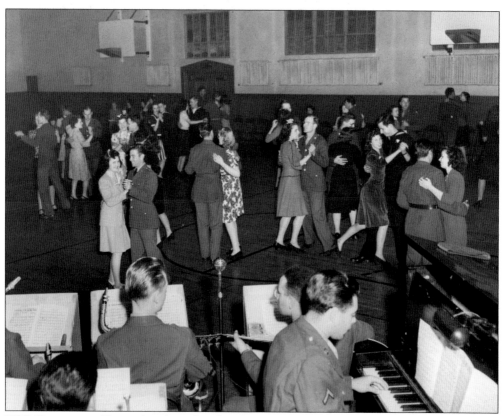

USO Dance with Band. A military band performs for a USO dance around 1943. With dancing and music during this turbulent era, romantic couples often quickly formed. Just as quickly, marriage applications were commonly applied for just weeks after a couple met at one of these events. (Courtesy Seattle Municipal Archives, 31069.)

ADMIT
ONE
COUPLE

FREE FREE

SEE A NATIONWIDE
RADIO BROADCAST
ORIGINATE

WASHINGTON NATIONAL GUARD
Military Ball

See and Hear

SKINNAY ENNIS AND ORCHESTRA
RAY HEATHERTON, Radio and Stage Star
IN PERSON

NEW ARMORY SATURDAY, NOVEMBER 27, 1948

3rd Avenue No. and Harrison Street 7 O'CLOCK

DRESS OPTIONAL

ARMORY DANCE. This is an entrance ticket for a dance to the Seattle Armory, which was built in 1939 and would later become part of the Seattle Center. Now the Seattle Center Armory/Center House, it has also been known as the Food Circus. This popular venue continues to host thousands of performances a year. The back of the ticket indicates that it belonged to a 17-year-old young man. (Author's collection.)

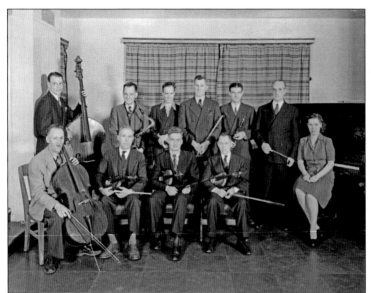

CITY LIGHT ORCHESTRA. Seen here is a May 1953 photograph of the City Light Employees' Association (CLEA) Orchestra. This group performed at many different locations and events, such as the American Legion, garden parties, and on the radio. (Courtesy Seattle Municipal Archives, 16281.)

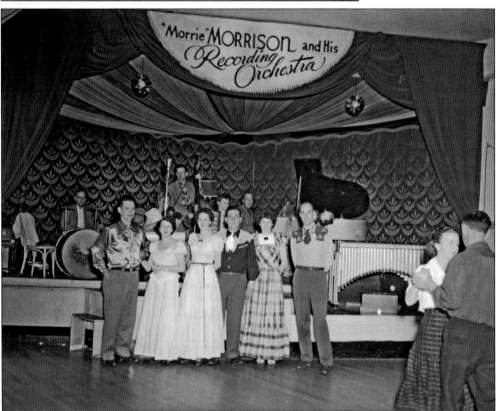

CITY LIGHT AND MORRIE MORRISON. Pictured is a City Light Employees' Association square dance with Morrie Morrison's Recording Orchestra in May 1950. The orchestra performed at many locations throughout the city, including the Palladium Ballroom on 125th Street and Aurora Avenue (admission was 75¢), the Metropolitan Theatre, and the Trianon Ballroom, once located on Third Avenue and Wall Street. (Courtesy Seattle Municipal Archives, 21258.)

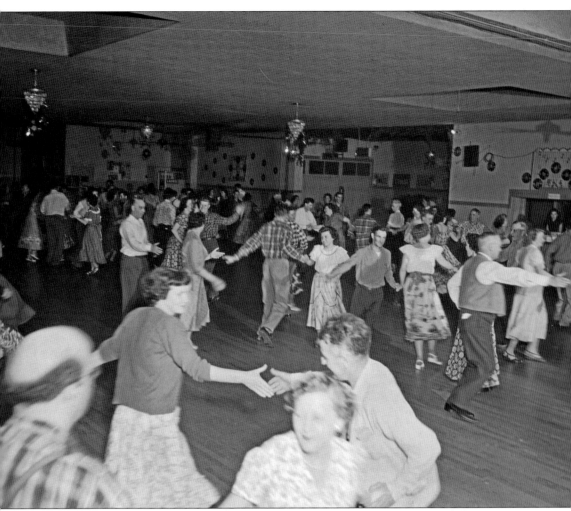

SQUARE DANCE. Pictured here is a lively square dance around 1950. Dances like these were common and very popular in such establishments such as the Aqua Barn, which was once located along Lake Washington and later moved to the Renton area. Square dances, polkas, schottisches, Swedish and Mexican waltzes, varsoviennes, the Boston two-step, the three-step, foxtrots, and the hambo have been popular dances in Seattle for over a century. (Courtesy Seattle Municipal Archives, 21251.)

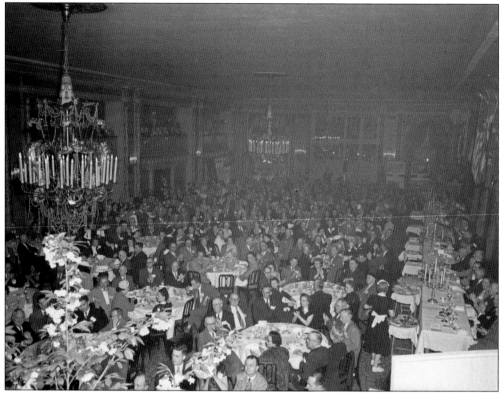

PUBLIC POWER ASSOCIATION. This image shows an April 1952 banquet gathering of the American Public Power Association Convention. The event, located in the elegant Spanish ballroom of the Olympic Hotel, was one of many activities that have occurred at the famous hotel. (Courtesy Seattle Municipal Archives, 25512.)

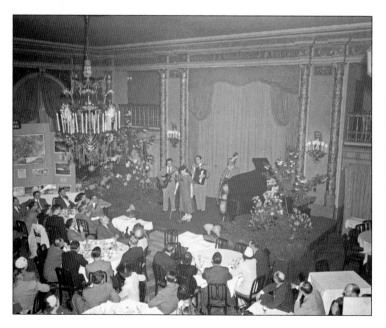

PUBLIC POWER ASSOCIATION BAND. Politics and music mixed in this smoke-filled venue. Musical guests performed in one of Seattle's most elegant ballrooms for delegates from across the United States at the American Public Power Association. (Courtesy Seattle Municipal Archives, 25559.)

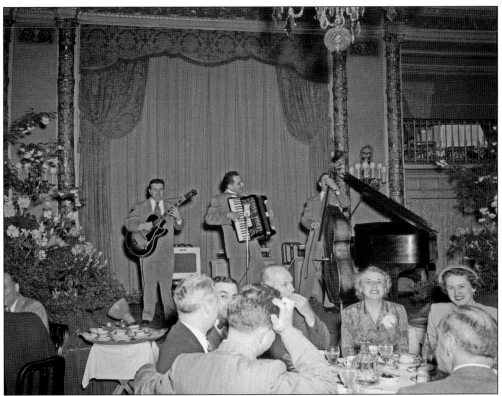

COMPANY PERFORMANCE. This is a close-up of a musical performance during the national Public Power Association Convention banquet. Nearly 200 delegates from around the country came to Seattle to discuss the US power supply. (Courtesy Seattle Municipal Archives, 26627.)

HULA DANCERS. Hawaiian music has played a rather prominent role in the Seattle-area music scene, from the rage of the steel guitar during the Alaska–Yukon–Pacific Exposition in 1909, through the hula dancers of the vaudeville era, to hula lessons offered at the YWCA. "Hula Girls," as they were called, made appearances at company events and occasionally at USO dances. (Courtesy Seattle Municipal Archives, 23315.)

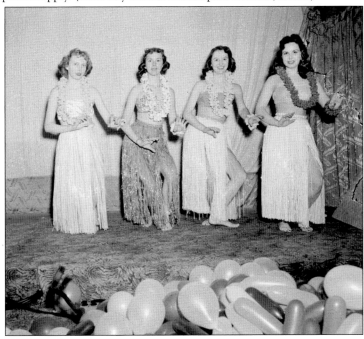

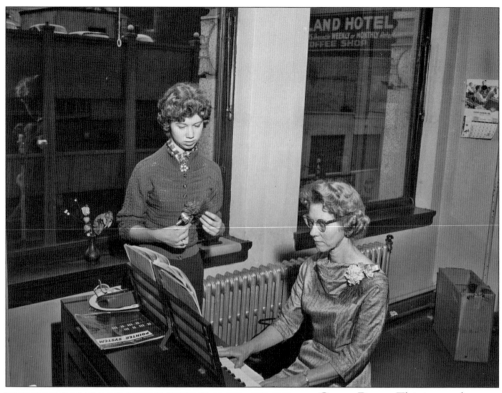

OFFICE PARTY. This image shows a little office entertainment in a downtown Seattle office during the 1959 winter holiday season. One employee plays the organ while another oversees. (Courtesy Seattle Municipal Archives, 63289.)

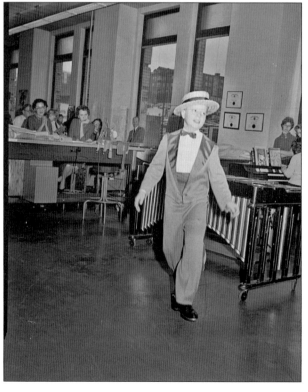

OFFICE PARTY ENTERTAINMENT. Tap dancing brings some holiday office cheer in what appears to be the City-County Building near Fourth Avenue and James Street. Although the young man taps in front of the xylophone, his accompaniment is the organist in the background. (Courtesy Seattle Municipal Archives, 63282.)

Four

ROADHOUSES, DANCE HALLS, AND LOUNGES

Seattle has always been a gracious host to a lively collection of dance halls, lounges, and roadhouses. This little area of the Pacific Northwest has seen world-famous musicians begin their musical careers in hopping music venues that posed as family restaurants during the day but turned into raucous dance halls by night.

Strict liquor and dance laws pushed many popular venues to open right outside the Seattle city limits. As early as the 1920s and well into the 1970s, the City of Seattle had a dance hall ordinance that was passed by the city council with a vote of five to three. It specifically focused on dance halls that catered to men only, who permitted women under the dance hall management. The ordinance stated, "Public dancehalls, or public dances, which cater to men only, and in connection with which dancing partners are furnished, are hereby prohibited." Dance hall licenses, in turn, cost $50. The fine for dancing without a license was $100.

Despite the laws, as famous jazz pianist Gerald Wiggins put it, "Seattle was a hot town then . . . the music was good and the money was like dirt. It was everywhere. Talk about the high rollers. You couldn't believe it. You know, boom time—shipyards and all this. Guys didn't know what to do with their paychecks. They did everything but go home."

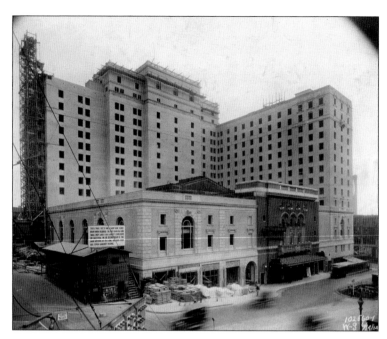

OLYMPIC HOTEL CONSTRUCTION. Built on property owned by the University of Washington, construction of the Olympic Hotel began in the early 1920s. The hotel was originally constructed around the Metropolitan Theatre, the darker structure in the center of the image. (Courtesy Seattle Public Library, shp_12438.)

OLYMPIC HOTEL. The completed hotel opened in 1924, built in the Italian Renaissance style and located on Fourth Avenue and Seneca Street. It was hailed as one of the grandest west of Chicago. The Metropolitan Theatre was later demolished to make room for enhancements to the hotel structure. (Courtesy Seattle Public Library, shp_11682.)

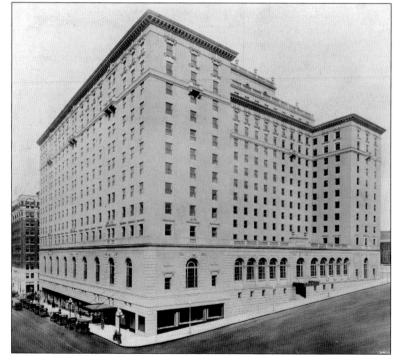

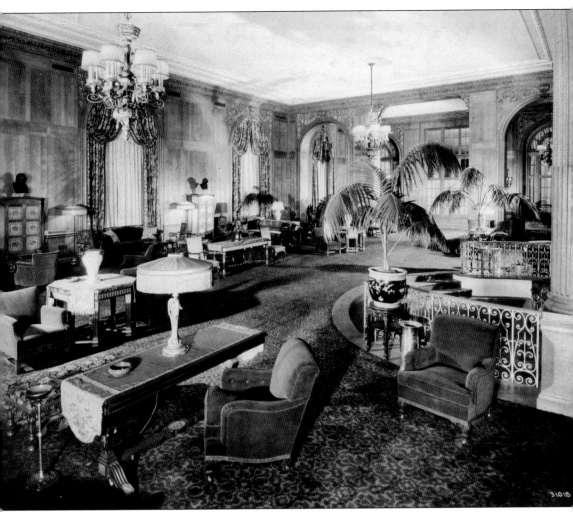

OLYMPIC HOTEL LOUNGE. The exquisite Spanish Ballroom lounge of the Olympic Hotel, now the Fairmont Olympic Hotel, reflected the taste and style of 1920s luxury. Serving as a setting for relaxation and peace for travelers and locals alike, this hotel, as well as its lounge, still hosts a wide range of entertainment. (Courtesy Seattle Public Library, shp_11688.)

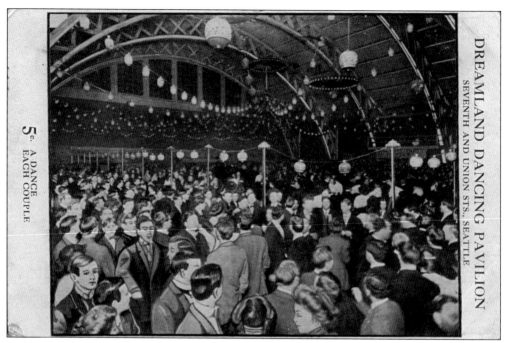

5¢ A DANCE EACH COUPLE

DREAMLAND 5¢ A DANCE.
This venue was originally
built in 1907 as a skating ring
on the corner of Seventh
Avenue and Union Street.
It later became a dance
hall, as well as a venue for
boxing, speeches, and other
community gatherings.
(Author's collection.)

**DREAMLAND DANCE
PAVILION.** This is a 1912
photograph of one of the
entrances to the Dreamland
Dance Pavilion. A final
dance was held in August
1924, after which the
building was demolished
to make way for the new
Eagles Hall, which still
stands today, housing ACT.
(Courtesy Seattle Municipal
Archives, 38854.)

50

LYONS MUSIC HALL AND THEATER. Once located at 1409 First Avenue near Union Street, this was a popular entertainment hall (center) in the downtown Seattle area. During the 1930s, dancing was available daily from 2:00 p.m. until 1:00 a.m. (Courtesy Seattle Municipal Archives, 32545.)

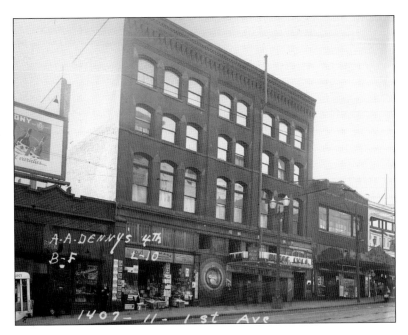

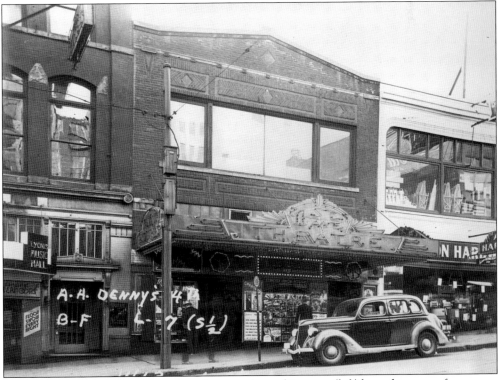

LYONS MUSIC HALL. Offering no cover charge at times, this venue (left) hosted many performances. One in particular featured Dottie Dee, covered in silver paint, in her *Silver Venus* shows. This building once stood around the corner from the Pike Place Market. (Courtesy Seattle Municipal Archives, 32544.)

CAFÉ DANCE. Pictured to the far left in 1940 is the dance hall in the Frye Hotel building, which now houses apartments, located at Third Avenue and Yesler Street in the Pioneer District of Seattle. Establishments such as these that wanted to offer dancing to customers had to apply for a costly license. (Courtesy Seattle Municipal Archives, 39626.)

HI-HO TAVERN. This is a 1957 picture of the Hi-Ho Tavern at 10401 Greenwood Avenue. A shuffleboard hub, dance hall, and popular tavern located in the Greenwood neighborhood of Seattle, this venue was also a target for several robberies and was subject to the dance licenses of Seattle. (Courtesy Seattle Municipal Archives, 70663.)

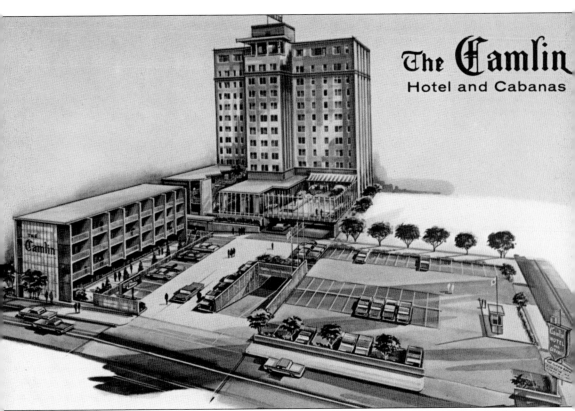

The Camlin
Hotel and Cabanas

THE CAMLIN. The Cloud Room, a hotel lounge once located at the very top of the Camlin at 1619 Ninth Avenue, opened two decades after the hotel was built and was a popular venue for luncheons, cocktails, piano music, and concert dinners. Near the Paramount Theatre and offering beautiful sights from the terrace, the venue was a favorite for many Seattleites and visitors. Musical guests such as John Lee Hooker, Bonnie Raitt, Miles Davis, Frank Sinatra, and Elvis Costello graced the establishment. (Author's collection.)

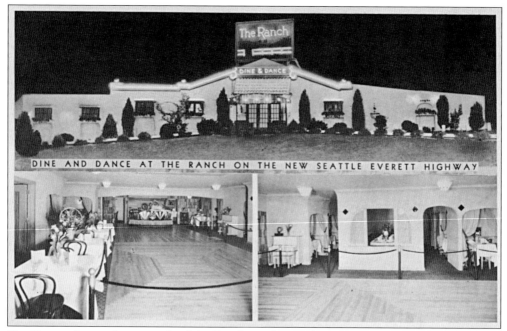

THE RANCH. Located just outside of the Seattle city limits, this venue once had floor shows every night of the week (except Sunday) at 11:00 p.m. and 1:00 a.m. with dancing from 9:00 p.m. until 2:30 a.m. and no cover charge. Offering mixed drinks at a time when Seattle's liquor laws were still restrictive, the roadhouse was popular for dinner, drinking, and dancing. In 1946, it became El Rancho. (Author's collection.)

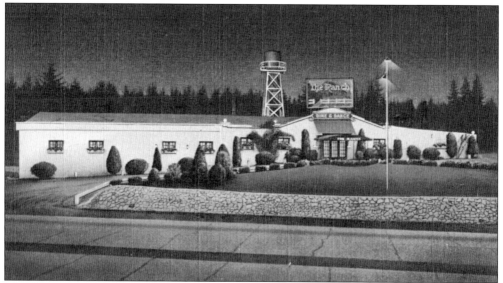

THE RANCH: SEATTLE'S THEATRE CAFÉ. This venue was once owned by popular business owner Doc Hamilton. Hamilton, who also owned Doc Hamilton's Barbeque Pit and a speakeasy in his own home at 1017 1/2 East Union Street—which police axed their way into in July 1924—helped create many jazz spots in Seattle. This particular location was hailed as the Seattle area's "biggest dining, dancing, and entertainment bargain" and welcomed performers from around the country. (Author's collection.)

Five

BALLET, OPERA, AND MUSICALS

From the first opera performance, Seattle has fought to bring drama, musicals, and ballet to the Pacific Northwest culture. Unfortunately, simply getting to Seattle was an obstacle. These challenges were gladly accepted by many different touring troupes, especially once the railroad made travel easier. For instance, the Cansinos, siblings Eduardo and Elisa, made several performances throughout the city during the early part of the 20th century, including at the Orpheum Theatre. Eduardo's theatrical genes did not end with him. His daughter later went on to take the stage as Rita Hayworth.

Today, events like the Pacific Northwest Ballet's presentation of *The Nutcracker* is a world-famous attraction, with show after show of sold-out performances. Relayed in this chapter are just a few of the venues that brought music and artists from around the world to the many venues of which are still very active to this day.

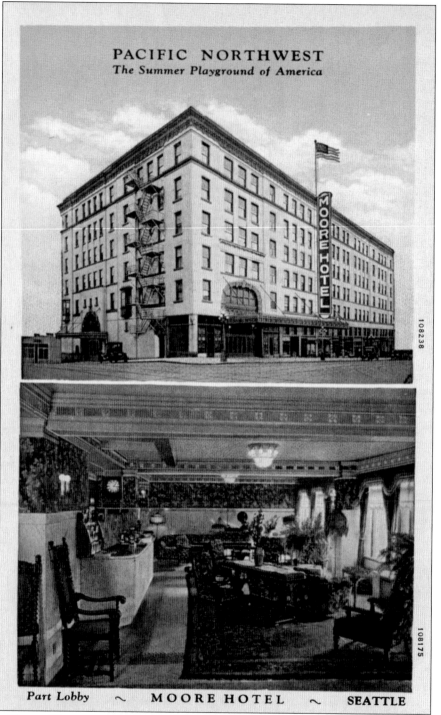

MOORE HOTEL. This postcard from the early 20th century shows the Moore Theatre, located at 1932 Second Avenue, and the hotel that adjoins it. A popular location during the Alaska–Yukon–Pacific Exposition, the establishment offered patrons the collective entertainment package of hotel accommodations and a basement swimming pool. (Author's collection.)

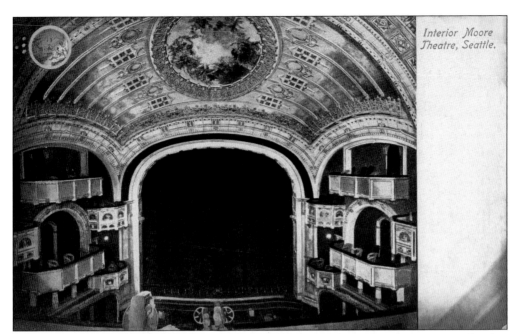

Interior Moore Theatre, Seattle.

MOORE THEATRE. Built in 1907, this theater's opening day in December was attended by nearly 3,000 people. *The Alaskan*, an operetta about the Klondike Gold Rush, debuted for a weeklong performance on the new theater stage. The Moore Theatre continues to be a very popular music venue to this day. (Author's collection.)

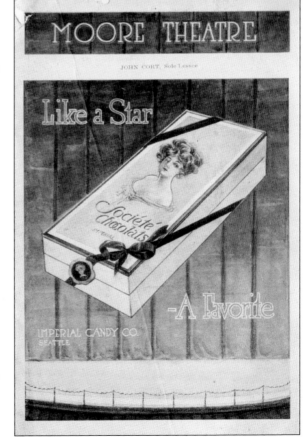

MOORE THEATRE

JOHN CORT, Sole Lessee

Like a Star

Société Chocolats

—A Favorite

IMPERIAL CANDY CO.
SEATTLE

MOORE PROGRAM, 1911. This is a program cover of a 1911 production at the Moore Theatre. In conjunction with the Seattle Symphony Orchestra, Pepito Arriola, advertised as "the marvelous boy pianist," performed at the venue in 1911. Ticket costs ranged between 75¢ and $3. (Author's collection.)

MOORE THEATER

JOHN CORT, Sole Lessee. **GEORGE HOOD, Gen. Mgr.**

SEATTLE'S LEADING PLAYHOUSE—THOROUGHLY FIREPROOF

BEN KETCHAM, Acting Manager. **W. F. FITZGERALD, Treasurer.**

Phones, Main 3340
Box Office hours: 10 a. m. to 9 p. m.
Doors open, 7:45 p. m.; Matinees, 1:45 p. m.
Curtains: Matinees, 2:20 p. m.; Nights, 8:20 p. m.
Reservations for seats held not later than 6 p. m. for evening performance; matinees 12 o'clock.
Matinees at the Moore Theatre Wednesdays and Saturdays.
Physicians may register their names and seat numbers at the box office so that any messages may be delivered promptly.

Mail orders for seats must be accompanied by remittance payable to Moore Theatre.
A ladies retiring room where wraps and hats may be checked has been provided, with a maid in attendance.
Lady patrons are respectfully requested to remove hats and not pin them to the backs of the leather seats.
A separate retiring room for balcony patrons on the balcony promenade.
Gentlemen's smoking and lounging room off the foyer.

HATS, COATS AND UMBRELLAS CHECKED FREE OF CHARGE IN THE CHECK ROOM.

Phone Main 7400

Hamill Taxi-Car Co.

AUTOMOBILES AT ALL HOURS

STAND—Washington Apartment

One Thing and Another

Contribute to the production of printing that escapes the waste-basket—the kind that is effective and accomplishes its purpose—the kind you want, but find it difficult to get.

Equipment, experience and a sincere interest in our work enable us to produce printed matter that really satisfies.

Phone Main 1666 **Gateway Printing Company** *500 Collins Bldg.*

MATINEE DAILY *Orpheum* **PHONE MAIN 5106**

PLAYING ONLY ADVANCED

VAUDEVILLE

PRICES, 25c TO 75c MATINEES, 25c AND 50c

THOROUGHLY FIREPROOF. Inside the 1911 program, management advertises the fire-safety protocols of the theater and reminds patrons of a few courtesies. An advertisement for the Orpheum Theatre can be found at the bottom of the page. (Author's collection.)

The PROGRAM Continued

WARD & CURRAN
The Emperors of Comedy, in Their Roaring Skit
"THE TERRIBLE JUDGE"

The Distinguished Character Actor
GEORGE BEBAN
And His Associate Players, Present
"THE SIGN OF THE ROSE"
A Play in One Act by Mr. Beban

CAST

The Detective......Samuel J. Murphy		The Cashier..........Edith MacBride	
The Wardman..........Frank Lynch		The Customer.......Florence Daniels	
The Mother...............Pearl Cook		The Italian................Mr. Beban	
The Father..........Richard Bartlett			

Time—Noon, on a summer day.

Scenery painted by Dodge & Castle. Scenery built by T. B. McDonald Company. Properties by John Brunton. All floral decorations used in this production from Art Floral Company.

CLAUDE MADDEN ORCHESTRA. The 1911 program continues with advertisements for candy, tea, a nice meal, and more music. The center details the characters in that evening's performance. (Author's collection.)

Memories of a Pleasant Evening

A great many people like to keep their programs as a souvenir or reminder of a particularly enjoyable evening. Here is space to jot down a few little aids to pleasant Memories of Day........Date...........1911.

Dinner at....................................

Saw the Play with	Friends or Distinguished People I Saw
....................................
....................................
....................................
....................................

Supper at....................................

Three Days, Commencing New Years

Alice Lloyd

And a Great Company of Supporting Vaudeville Acts

16

MEMORIES OF A PLEASANT EVENING. This same 1911 program concludes with a section for patrons to notate their memories of the evening's performance. The lower half of the page advertises an up-and-coming vaudeville performance. (Author's collection.)

MOORE THEATRE

JOHN CORT, Sole Lessee. GEORGE HOOD, Gen. Mgr.
SEATTLE'S LEADING PLAYHOUSE—THOROUGHLY FIREPROOF
BEN KETCHAM, Aacting Manager. W. F. FITZGERALD, Treasurer

ARTHUR BYRON
in "To Day" at the Moore week commencing Sunday, March 21.

MOORE PROGRAM COVER, 1915. A Moore Theatre program advertises a 1915 performance of *Today*. At the top, the state-of-the-art theater continues to advertise its fire-safety advancements. (Author's collection.)

**THIS THEATRE UNDER NORMAL CONDITIONS WITH EVERY SEAT OCCU-
PIED CAN BE EMPTIED IN LESS THAN THREE MINUTES**

Immediately upon being shown to your seat, locate the nearest **EXIT** to your seat. In case of fire, **WALK (DO NOT RUN)** to that EXIT. Keep cool, and try to help your neighbor.

The PROGRAM Continued

ONE WEEK, BEGINNING SUNDAY NIGHT, MARCH 7, 1915
Matinees Wednesday, Friday and Saturday
The Winter Garden Company presents
THE DELIRIOUS DANCE CRAZE

"The Whirl of the World"

In Two Acts and Twelve Scenes

Dialogue and Lyrics by Harold Atteridge. Music by Sigmund Romberg. Staged under the direction of William J. Wilson. Costumes designed by Melville Ellis.

THE CAST
(In the Order of Their Appearance.)

JacquesGeorge Moon	Sergeant of Police...............Daniel Morris
BeppoDaniel Morris	A GendarmeM. Norman
MauriceRoy Goodrich	A GendarmeHarry Weber
PierreWyclif Parker	Captain of the S. S. Vaterland..Edward Cutler
Viola, a music hall girl......Elizabeth Goodall	Purser of the S. S. Vaterland..Eugene Howard
Jack Phillips, known later as Harrison	A Wireless Operator............Edward Cutler
GrayworthBurrell Barbaretto	AhmedGeorge Moon
M. Archambault................Edward Cutler	HassanDaniel Morris
Marquis Tullyrand.............John T. Murray	Cleopatra II...................Texas Guinan
FootmanM. Rio	The Mysterious Arabian.......Eugene Howard
Claudie, a valet.................Roy Goodrich	
General Pavlo, President of the Amber	
ClubClarence Harvey	**PERSONNEL OF THE CHORUS**

Archie Picadilly ⎫ Members of ⎧....Jack Laughlin
Bertie Strand.. ⎬ the ⎬ Charles Townsend
Francois....... ⎭ Amber Club ⎩Roy Goodrich

Annette........⎫ ⎧.Trixie Raymond
Babette.........⎪ Ladies of ⎪....Bessie Skeer
Marguerite......⎪ the ⎪.....June Price
Elsie...........⎬ Amber ⎬.Evelyn Carbery
Clarice.........⎪ Club ⎪...Dorothy Page
Louise.........⎪ ⎪.....Emily Russ
Lorette.........⎭ ⎩.....Ann Perine

Misses Eleanor Ryley, Helen Glenmore, Gladys Benjamin, June Price, Dorothy Page, Ann Perine, Betty Barclay, Frances Heurich, Elizabeth Francis, Lyda Carlisle, Irma Benzing, Helen Henkel, Bessie Skeer, Emily Russ, Evelyn Carbery, Pearl Evans, Georgica Storm, Gertrude Platt, Pearl Betts, Trixie Raymond, Mazie Lawless, Rosella Meyers, Mazie Gilmore, Lillian Watson, Dot Lambert, Kathryn Robertson, Emma Haig, Mabel Benelisha, Hilda Wright, Hazel Snyder, Nina Pastorelli, Louise Furlong, Winifred Dunn.

Messrs. Jack Laughlin, Roy Goodrich, Otto Henkel, Art Garvey, Larry Mack, Charles Townsend, Stanley Rayburn, William Wilder, Charles Hughes.

Sammy Meyers...................Willie Howard
Steward of the Amber Club....Eugene Howard
NanetteJuliette Lippe
FifiTexas Guinan
OliviaLucille Cavanaugh
Captain of the Police...........Roy Goodrich

All Modern Dresses by Joseph.

WALK (DO NOT RUN). Inside the 1915 program, additional patron-directed protocols can be found, as well as a list of performers in that evenings' show, *The Whirl of the World*. This dance-dominated performance was highly acclaimed. Lucille Cavanaugh, who played Olivia, was quoted as saying that dancing is the "royal road to beauty." (Author's collection.)

The PROGRAM Continued

SYNOPSIS OF SCENES

ACT I.

Scene 1—Maxixe Restaurant, Paris. (Young Bros.)
Scene 2—Rue de Tango, Paris. (Young Bros.)
Scene 3—The Amber Club, Paris. (Young Bros.)
Scene 4—A Street in Havre. (Robert Law.)
Scene 5—Rue de Tango. (Young Bros.)
Scene 6—The Dock in Havre. (Young Bros.)

INTERMISSION OF TEN MINUTES

ACT II.

Scene 1—Lounge on the S. S. Vaterland. (Young Bros.)
Scene 2—The Wireless Room. (Young Bros.)
Scene 3—Off the Coast of Nova Scotia. (Young Bros.)
Scene 4—Exterior of the Century Opera House, New York. (Young Bros.)
Scene 5—The Arabian Nights Ball at Madison Square Garden, New York. (Young Bros.)
(Burning Steamship Effect by Frank D. Thomas. Patented in all Countries.)

MUSIC PROGRAMME

"A Broadway in Paree," "Ragtime Pinafore," "Twentieth Century Rag," and "Ragtime Arabian Nights," by Henry Lehman.

AFTER-THEATER SUPPER. Another page inside the 1915 program advertises the Rathskeller cabaret and the Hollywood Gardens florists, as well as a watch repair shop. A synopsis of the performance scenes is also detailed. (Author's collection.)

"TODAY"

A genuine drama, which abounds in thrills and has each act end in a situation more tense than the preceding one until the final curtain holds the audience spellbound, is the alluring promise held forth by the Manuscript Producing Company, which will present at the Moore Theater, March 21, the George Broadhurst-Abraham Schomer society play, "To-day."

"This is a big bill to fill," you will say; yet "To-day" must have some of the elements of the unusual about it, else it never would have remained all last season at the Forty-eighth Street Theater, New York, nor run all this season in both Boston and Chicago.

Briefly told, the play of "To-day" concerns an honorable young real estate agent and his wife. They have been enjoying every luxury when the husband meets financial reverses. He starts to recoup his losses, and his good old mother and father help him all they can. But his young wife is dissatisfied because she can no longer have the "fine feathers" of their prosperous days.

How she learns "the easiest way" to obtain them, and how her unsuspecting husband in the ordinary pursuit of his business stumbles across her path, go to bring about a climax which literally chains the audience to its seat, and leaves it tense and gasping.

Arthur Byron is the leading man of what has been styled "The Perfect Company." He will be supported by Bertha Mann, Clare Lindsay, Marguerite St. John, Alice Gale, Herman Gerold, Harry MacFayden and Kathryn Keys.

The PROGRAM Continued

ACT I—Scene 1.

1. "Come On In, the Dancing's Fine"............................Guests at the Maxixe Restaurant
2. "A Broadway in Paree"..Elizabeth Goodall and Chorus
3. "Nobody Was in Love with Me"................................Burrell Barbaretto and Chorus

Scene 2.

4. "The Whirl of the World"...John T. Murray

Scene 3.

5. "The Amber Club"..Members of the Club
6. "A Dancing Romeo"......................Burrell Barbaretto, Trixie Raymond and Chorus
7. "A College Boy"...Willie Howard
8. "Life's Dress Parade"..Juliette Lippe and Chorus
9. "Hello, Little Miss U. S. A."...Texas Guinan and Chorus
10. "The Dance of the Fortune Wheel"....................Lucille Cavanaugh and Wyclif Parker
11. "The American Maxixe"................................Lucille Cavanaugh and Wyclif Parker
12. "The Twentieth Century Rag".............................Burrell Barbaretto and Chorus

Scene 5.

13. "What'll"..John T. Murray

Scene 6.

14. "All Aboard"...The Travelers
15. "The Ragtime Pinafore"...Willie Howard and Chorus
16. "Everybody Means It When They Say 'Good-bye' "...........................Ensemble

ACT II—Scene 1.

17. "A Lovely Trip"..The Travelers
18. "The Visit"..John T. Murray
19. "I'm Manhattan Mad"...Texas Guinan and Chorus
20. Impersonations ..Willie Howard

Scene 4.

21. "The Whirl of the Opera"..Eugene and Willie Howard

Between Acts and after show, CALHOUN HOTEL BUFFET, across from Moore Theater.

One Thing and Another

Contribute to the production of printing that escapes the waste-basket—the kind that is effective and accomplishes its purpose—the kind you want, but find it difficult to get.

Equipment, experience and a sincere interest in our work enables us to produce printed matter that really satisfies.

Phone Elliott 1666 **Gateway Printing Company** 500 Collins Bldg.

ONE THING AND ANOTHER. Although advertised on the cover, pictured here is a synopsis providing more detail about *Today*, a play that would be performed in the upcoming weeks. Starring Arthur Byron and billed as a "society play," *Today* portrayed a young and wealthy couple's view on financial success. (Author's collection.)

The PROGRAM Continued

Scene 5.

22.	"Oh, Allah"..	The Arabian Masqueraders
23.	"The Pavlowa Gavotte"........................	Lucille Cavanaugh and Wyclif Parker
24.	"Dance Eccentric"...............................	Moon and Morris
25.	"My Cleopatra Girl"............................	Texas Guinan and Chorus
26.	"Ragtime Arabian Nights"......................	Eugene Howard and Chorus
27.	Finale...	The Arabian Masqueraders

FOR THE WINTER GARDEN COMPANY

Manager ..Gilman Haskell
Business Manager.......................................H. L. Davidson
Musical Director.......................................Hilding Anderson
Stage Director..Arthur Evans
Stage Manager..F. B. Wells

All costumes other than modern dresses by Max & Mahieu. Headdresses used in Act II by Paul Poiret; furnished by John Wanamaker. Shoes by Miller. Properties by the Shubert Theatrical Company's Property Department. Electrical Effects by the Winter Garden Electrical Department. Lilas de Rigaud by Perfumerie V. Rigaud, Paris.

HOTEL BUTLER ORCHESTRA. This is a 1915 program advertisement for the popular Hotel Butler. Hailed as a refined establishment for dinner and dancing, the famous Rose Room in the hotel commonly offered alcohol during the Prohibition era. Today, a majority of the building has been turned into a parking garage. (Author's collection.)

Beautiful Hair —— Beautiful Features

The skilled hand of the expert can work wonders in the designing of coiffures to obtain striking and exquisite effects.

Our experts assure you the most efficient service in hair dressing, scalp and facial massage and manicuring.

You'll find the prices reasonable.

Have your hair permanenty waved. "Nestle's" process is guaranteed non-injurios.

Mrs. Mabel M. Harris

THORNTON'S
The most up-to-date hair store in Seattle

MAIN 4034 303 MADISON ST.

We Solicit Your Patronage in

Cleaning, Pressing, Dyeing and Alterations

and Assure you Quality, Service and Reliability

Berlin Dye Works—Elliott 5396

We call any where, any time, for any thing in our line

AMERICAN CAFE *Fourth Ave. and Pike St.*

ERNEST GIANETTI, Manager

CABARET VAUDEVILLE 8 to 1
NO INTERMISSIONS
E. K. MAITLAND, Amusement Manager

We serve Italian Dinner with Wine, 50c

AMERICAN CAFÉ. Another page in the 1915 Moore Theatre program advertises hair products. The American Café also advertises cabaret, vaudeville, and a 50¢ dinner with wine. The café opened in 1907 under management of the American Catering Company and was hailed as one of most prestigious establishments of its kind in the West. Along with beer, food, music, and lobster, a patron could also buy "Laughing Water," water reportedly from Minehaha Falls. (Author's collection.)

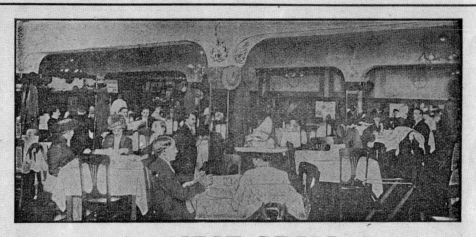

ADVANCED VAUDEVILLE. Pictured here is the final page of this 1915 program. Advertisements for the Nanking Café, the Orpheum Theatre, a liquor store, and the Northern Pacific Railway blatantly cover the page. (Author's collection.)

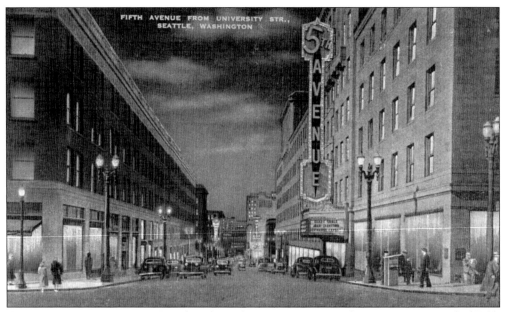

THE 5TH AVENUE THEATRE. Seattle is lit with entertainment in this evening postcard of Fifth Avenue. Built in 1926, the 5th Avenue Theatre was praised as one of the most lavish in the city. The interior was molded after Bejing's Summer Palace, Temple of Heaven, and the throne room of the Imperial Palace. The theater closed in 1978, but thanks to a caring community it was refurbished and opened again in 1989. It has been a successful performance hub to this day. (Author's collection.)

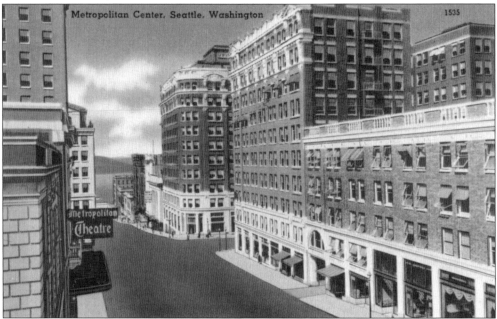

METROPOLITAN THEATRE CITY CENTER. Opened in 1911 on University Street between Fourth and Fifth Avenues, this performance center saw a wide range of entertainment. One in particular was Ernestine Anderson, who at the age of 17 sang at this venue during a Northwest jazz series in November 1946. (Author's collection.)

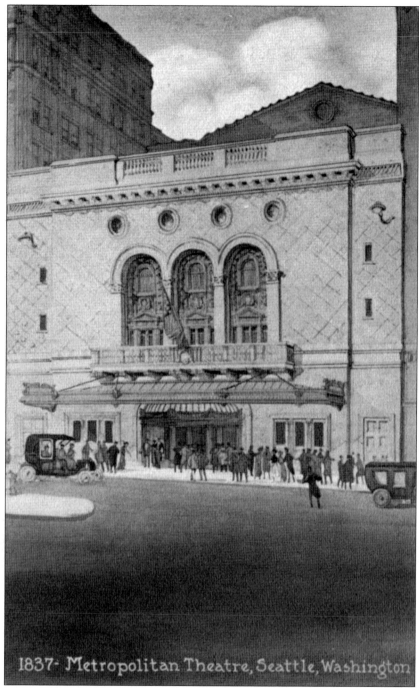

1837- Metropolitan Theatre, Seattle, Washington

METROPOLITAN THEATRE. This much-admired theater hosted live performances as well as films. The final performance of any kind was *What Every Woman Knows* on December 4, 1954. At the end of the show, all cast members remained on stage, and Helen Hayes addressed the audience with a eulogy for the theater. Bagpipers performed the song "Auld Lang Syne" as the crowd exited the establishment. This location is now the driveway of the Olympic Fairmont Hotel. (Author's collection.)

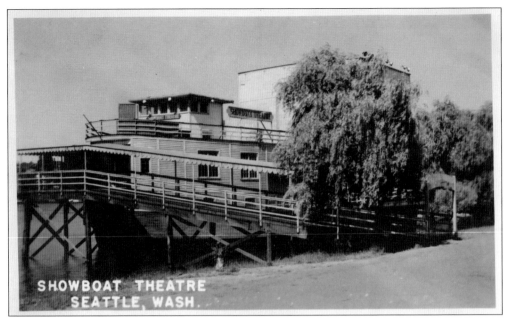

SHOWBOAT THEATRE. Although not an actual boat, the Showboat was built on pilings in Lake Washington, seated 223 people, and had a revolving stage. This theater was created in part by Glenn Hughes, professor and director of the Division of Drama at the University of Washington. The first performance, *Charley's Aunt*, was held on September 23, 1938. (Author's collection.)

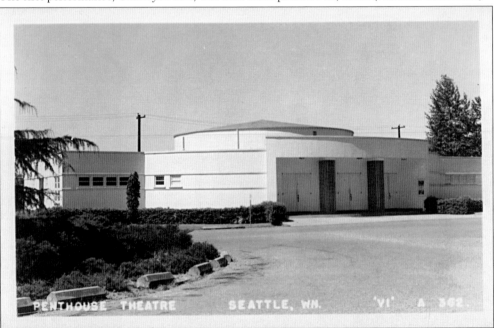

PENTHOUSE THEATRE. Another theater on the grounds of the University of Washington was the Penthouse Theatre. It opened on May 16, 1940, with the production of *Spring Dance* and was built in part with Works Progress Administration funds. Designed by Glenn Hughes and John Conway, it was one of the first theater-in-the-round venues constructed in the United States. (Author's collection.)

DOROTHY FISHER BALLET DANCER.
This is a 1957 photograph of a
dancer with the Dorothy Fisher
Ballet. The Dorothy Fisher Ballet
Center opened on August 28,
1957, and was located at 1520
Sixth Avenue. Auditions for
the Aqua Theater were held at
this venue. (Photograph by John
Hardin, courtesy Seattle Municipal
Archives, 29958.)

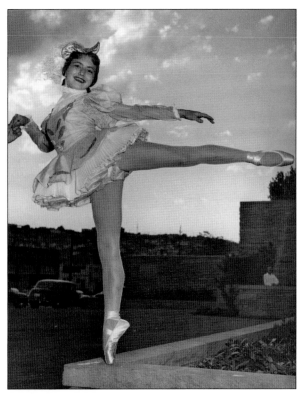

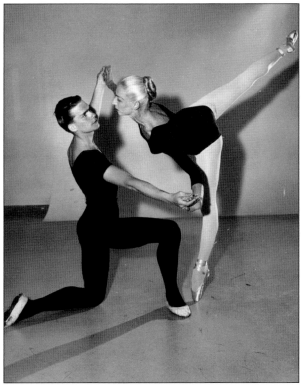

SEWARD PARK BALLET PROGRAM.
This is a 1956 photograph of two
dancers, Martin Buchner and
Coby Larsen, rehearsing for the
Seward Park Ballet Program. On
opening night of *Carousel* at the
Aqua Theater, Larsen, who was the
lead dancer, broke a bone in her
foot during a dance. Despite what
must have been excruciating pain,
she continued her performance
and did not notify show directors.
(Photograph by James O. Snedden,
courtesy Seattle Municipal
Archives, 29972.)

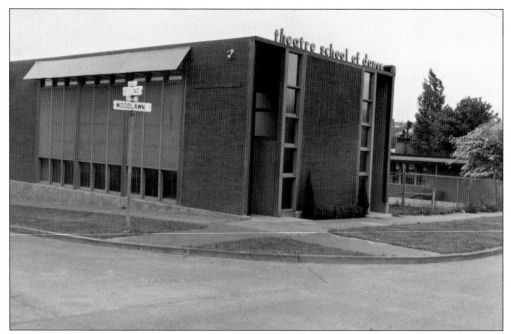

THEATRE SCHOOL OF DANCE. This venue, located at 6600 First Avenue Northeast in the Greenlake neighborhood, helped teach beginners and adult professionals various dance forms. Performance opportunities were available to students, and many of those were sold-out acts held at the Women's Century Theater. (Courtesy Seattle Municipal Archives, 75512.)

THE NEIGHBORHOOD DANCE SCHOOL. School directors Giovanni Giglio and Henrietta Hansen arrived in Seattle during the 1940s ready to advance their professional dancing careers. To offset some costs while rehearsing for their performances, they began providing dance lessons. Over time the school grew, and by 1963 it had over 400 students enrolled. (Courtesy Seattle Municipal Archives, 75513.)

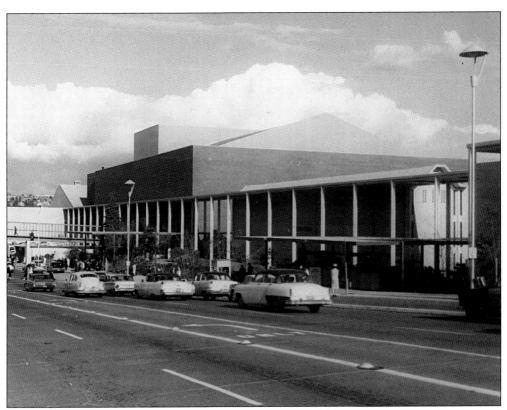

SEATTLE OPERA HOUSE. This is a 1962 view of the Seattle Opera House shortly after reconstruction. Located at the Seattle Center at 225 Mercer Street, the Seattle Opera House was built from the shell of the Seattle Civic Auditorium. B. Marcus Priteca, who helped design some Pantages vaudeville halls, was a consulting architect for this new building. (Courtesy Seattle Public Library, spl_wl_sec_01221.)

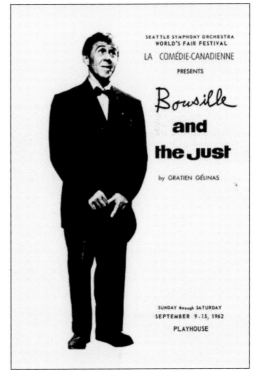

SEATTLE SYMPHONY ORCHESTRA. Accompanied by the Seattle Symphony Orchestra, the performance of *Bousille and the Just* was held at the Center Playhouse during the 1962 Seattle World's Fair. This performance marked the official opening of Canada Week at the fair. (Courtesy Seattle Public Library, spl_c21_2819027.)

SEATTLE'S ORPHEUM THEATRE. The new Orpheum Theatre opened in 1927 and was located on the corner of Westlake and Sixth Avenues, which is now the site of the Westin Hotel towers. This new building, significantly larger than the last venue on Second Avenue, was built in the Spanish Renaissance style. The Orpheum Theatre played a significant role in providing the Seattle community with music, dance, comedy, and drama. (Photograph by John Morse, courtesy Seattle Municipal Archives, 30700.)

ORPHEUM FROM SIXTH AVENUE. Looking north on Sixth Avenue across Olive Way and Westlake Avenue, this scene shows the back of the Orpheum Theatre (left). It offered wide entertainment options, from such movies as *Attack of the Crab Monsters* to a live performance by the Seattle Symphony Orchestra for 7,500 schoolchildren. This image was captured just a few years before it was razed in 1967. (Photograph by John Morse, courtesy Seattle Municipal Archives, 30701.)

PONCHO THEATER. Originating in the Children's Zoo section of the Woodland Park Zoo, this theater was built with the assistance of charity donations, such as those from Patrons of Northwest Civic, Cultural and Charitable Organizations (PONCHO), over several years. The theater held a debut performance in 1971 with a two-night run of singers presented by the Opera on Wheels association. (Courtesy Seattle Municipal Archives, 30783.)

PONCHO THEATER SIDEWALK VIEW. By the mid-1970s, this theater was hosting performances by the Seattle Children's Theatre. Thanks to significant dedication by volunteers, charity groups, and patrons of the arts, the Seattle Children's Theatre group became successful and now has a state-of-the-art venue located in the Seattle Center. It is ranked as one of the top 20 professional regional theaters in the country. (Courtesy Seattle Municipal Archives, 30784.)

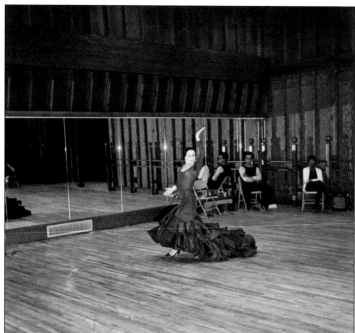

DANCING IN MADRONA. The Madrona Dance Studio is located at 800 Lake Washington Boulevard on the waterfront of Lake Washington. This venue continues to offer dance classes to adults and children, including lessons in ballet and contemporary and folk dance. (Courtesy Seattle Municipal Archives, 29820.)

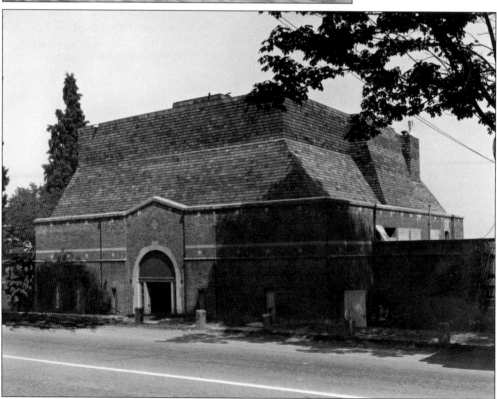

MADRONA DANCE STUDIO. Currently managed by the Seattle Parks and Recreation Department, this establishment was once a bathhouse. The City of Seattle converted the building into a dance studio in 1971. (Courtesy Seattle Municipal Archives, 29817.)

Six

THE 1962 WORLD'S FAIR

The Seattle World's Fair, also known as Century 21, made a lasting impact on Seattleites and visitors alike. Many of the buildings that housed so many different exhibits and performances for the fair still host thousands of events annually, which helps keep some essence of the fair alive for current and future generations.

The Century 21 fair focused heavily on science and the state-of-the-art future, as well tributes to different cultures from around the world. A rather risqué area was also built for those interested in shimmering, shimmying ladies. On the night before the fair opened to millions of visitors on April 21, 1962, a grand celebration was held in the Grand Ballroom of the Olympic Hotel, and the Space Needle was christened at midnight. Many of the locations discussed in the next chapter still play a vital role in bringing music, education, culture, sports, comedy, drama, and dance to the Seattle area.

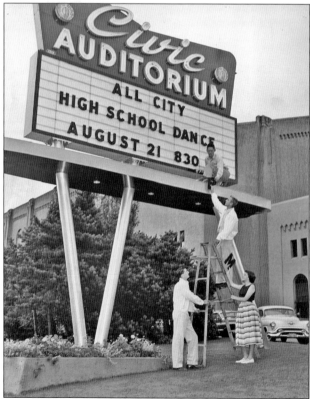

CIVIC AUDITORIUM AERIAL VIEW. This is a 1928 view of the Seattle Civic Center shortly after it was constructed. Built on top of land once owned by the Boren family, structure funding was initiated by saloon owner James Osborne, prompting the building to be dubbed by some as "the house that suds built." (Courtesy Seattle Public Library, shp_14124.)

CIVIC AUDITORIUM HIGH SCHOOL DANCE. In this image, a sign is being erected advertising a 1954 Seattle-area high school dance at the Civic Auditorium. All city high school dances, often attended by thousands, had occurred at the civic center since as early as 1935. (Courtesy Seattle Municipal Archives, 64017.)

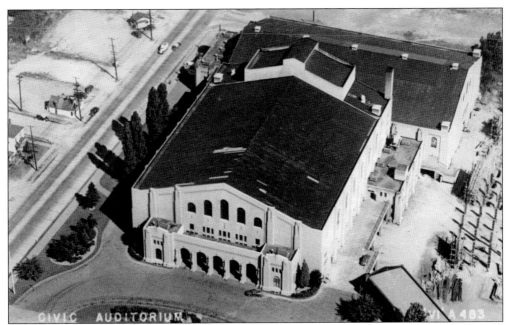

CIVIC AUDITORIUM. This is an aerial view of 321 Mercer Street. Before this building became the Seattle Opera House, it hosted a wide variety of events, including musical performances, ice-skating, and lectures by Amelia Earhart in 1933. (Author's collection.)

CIVIC AUDITORIUM RESIDENTIAL VIEW. In preparation for the upcoming 1962 World's Fair, this 1957 view portrays the residential neighborhood that surrounded what would become the Seattle Center. The future Seattle Opera House is pictured in the center. (Courtesy Seattle Public Library, spl_wl_sec_00201.)

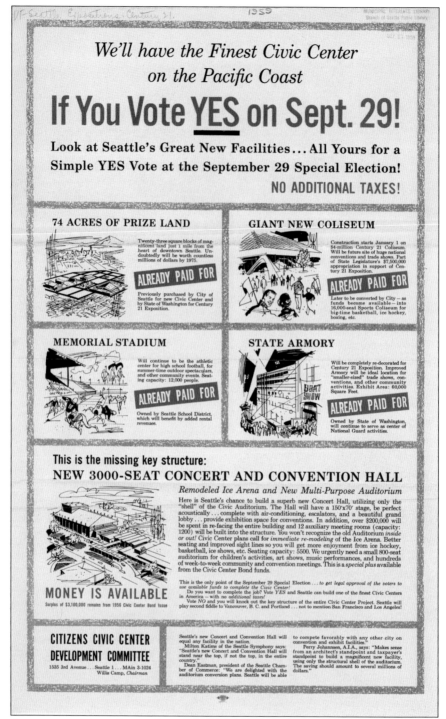

We'll have the Finest Civic Center
on the Pacific Coast

If You Vote YES on Sept. 29!

Look at Seattle's Great New Facilities... All Yours for a Simple YES Vote at the September 29 Special Election!

NO ADDITIONAL TAXES!

74 ACRES OF PRIZE LAND

Twenty-three square blocks of magnificent land just 1 mile from the heart of downtown Seattle. Undoubtedly will be worth countless millions of dollars by 1975.

ALREADY PAID FOR

Previously purchased by City of Seattle for new Civic Center and by State of Washington for Century 21 Exposition.

GIANT NEW COLISEUM

Construction starts January 1 on $4-million Century 21 Coliseum. Will be future site of huge national conventions and trade shows. Part of State Legislature's $7,500,000 appropriation in support of Century 21 Exposition.

ALREADY PAID FOR

Later to be converted by City — as funds become available — into 16,000-seat Sports Coliseum for big-time basketball, ice hockey, boxing, etc.

MEMORIAL STADIUM

Will continue to be the athletic center for high school football, for summer-time outdoor spectaculars, and other community events. Seating capacity: 12,000 people.

ALREADY PAID FOR

Owned by Seattle School District, which will benefit by added rental revenues.

STATE ARMORY

Will be completely re-decorated for Century 21 Exposition. Improved Armory will be ideal location for "smaller-sized" trade shows, conventions, and other community activities. Exhibit Area: 60,000 Square Feet.

ALREADY PAID FOR

Owned by State of Washington, will continue to serve as center of National Guard activities.

This is the missing key structure:
NEW 3000-SEAT CONCERT AND CONVENTION HALL
Remodeled Ice Arena and New Multi-Purpose Auditorium

Here is Seattle's chance to build a superb new Concert Hall, utilizing only the "shell" of the Civic Auditorium. The Hall will have a 150'x70' stage, be perfect acoustically ... complete with air-conditioning, escalators, and a beautiful grand lobby ... provide exhibition space for conventions. In addition, over $200,000 will be spent in re-facing the entire building and 12 auxiliary meeting rooms (capacity: 1200) will be built into the structure. You won't recognize the old Auditorium *inside or out!* Civic Center plans call for *immediate re-modeling* of the Ice Arena. Better seating and improved sight lines so you will get more enjoyment from ice hockey, basketball, ice shows, etc. Seating capacity: 5500. We urgently need a small 800-seat auditorium for children's activities, art shows, music performances, and hundreds of week-to-week community and convention meetings. This is a *special plus* available from the Civic Center Bond funds.

This is the only point of the September 29 Special Election ... *to get legal approval of the voters to use available funds to complete the Civic Center!*

Do you want to complete the job? Vote YES and Seattle can build one of the finest Civic Centers in America — with no *additional taxes!*

Vote NO and you will knock out the key structure of the entire Civic Center Project. Seattle will play second fiddle to Vancouver, B. C. and Portland ... not to mention San Francisco and Los Angeles!

MONEY IS AVAILABLE

Surplus of $3,100,000 remains from 1956 Civic Center Bond Issue

CITIZENS CIVIC CENTER DEVELOPMENT COMMITTEE

1535 3rd Avenue ... Seattle 1 ... MAin 3-1024
Willis Camp, *Chairman*

Seattle's new Concert and Convention Hall will equal any facility in the nation.

Milton Katims of the Seattle Symphony says: "Seattle's new Concert and Convention Hall will stand near the top, if not the top, in the entire country."

Dean Eastman, president of the Seattle Chamber of Commerce: "We are delighted with the auditorium conversion plans. Seattle will be able to compete favorably with any other city on convention and exhibit facilities."

Perry Johannsen, A.I.A., says: "Makes sense from an architect's standpoint and taxpayer's standpoint to build a magnificent new facility, using only the structural shell of the auditorium. The saving should amount to several millions of dollars."

Civic Auditorium Vote. Pictured is a September 1959 promotion for Seattle residents to vote on revisions to the buildings located on the future grounds of the 1962 World's Fair. This flyer promotion boasted the possibility of air-conditioning, escalators, and a new grand lobby. (Courtesy Seattle Public Library, spl_c21_2125874.)

COLISEUM CONSTRUCTION. Seen here is a construction photograph of the beginning foundations of the Washington State Coliseum, also known as Coliseum 21 (later Key Arena). At the time, it was one of the largest span structures in the world. At its apex, the aluminum roof reaches 110 feet into the air. (Courtesy Seattle Public Library, spl_wl_sec_00470.)

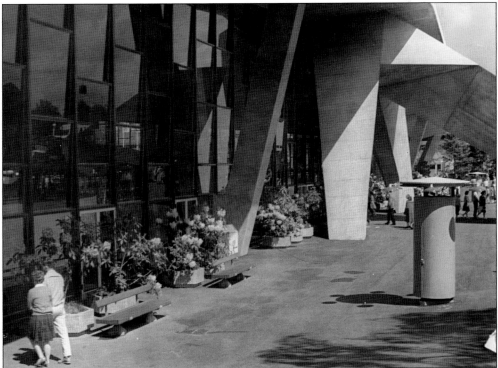

COLISEUM 21. This is a photograph of a completed side of the Washington State Coliseum. This particular World's Fair was unique in that many structures were built for it, as well as permanent structures for events after the fair. This venue is still a popular location to see world-famous musical attractions. (Courtesy Seattle Public Library, spl_wl_exp_00656.)

BACKSTAGE, USA. Located in the adult entertainment section of the 1962 World's Fair, also known as Show Street, "Backstage, USA" was an entertainment venue that gave spectators walk-through performances of showgirls and their dressing rooms. Other venues in this location included singing waitresses at the *Gay 90's Club* and *Girls of the Galaxy*, where patrons could take photographs of models. (Courtesy Seattle Municipal Archives, spl_wl_exp_00874.)

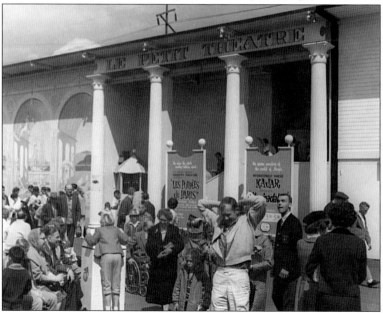

LE PETIT THEATRE. This venue was also on Show Street in an area in the northeast corner of the fairgrounds. This theater provided variety shows and advertised seating that would rotate around the stage. (Courtesy Seattle Public Library, spl_wl_exp_00858.)

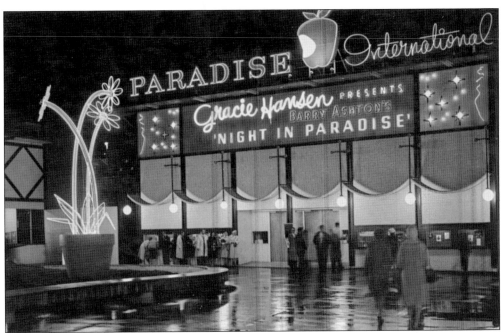

PARADISE INTERNATIONAL. This was a very popular Vegas-style vaudeville hall on Show Street at the 1962 World's Fair. The theater sat 700 people, presented four shows a night, and entertained patrons with glitz, glamour, and extravagance. (Author's collection.)

GRACIE HANSEN. Pictured here is Gracie Hansen (front left), dressed in her finest and attending the 10th anniversary of the World's Fair. As proprietor of the Paradise International venue, the creative and inventive Hansen was also known as witty, unforgettable, and brash. (Courtesy Seattle Public Library, spl_wl_sec_01793.)

MURAL AMPHITHEATRE AUDIENCE. Mural artist Paul Horiuchi was born in Japan and moved to Seattle in 1946. He passed away in 1999, leaving the world with a full history of beautiful collage and abstract art. This particular piece is meant to invoke the natural beauty and colors of the Pacific Northwest. Seattle Center's Mural Amphitheatre continues to be a popular location to showcase musical acts from around the world. (Courtesy Seattle Public Library, spl_wl_sec_00364.)

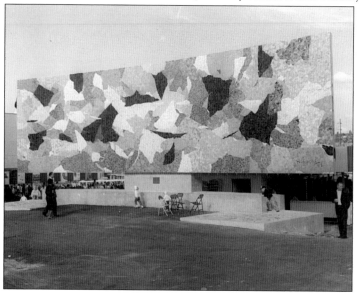

MURAL STAGE. *Seattle Mural* by Horiuchi is both a piece of art and a music stage. The 60-foot cycloramic wall consists of 54 panels in 160 color variations made out of Venetian glass, making it a unique and lovely sound-reflecting acoustic backdrop for an amphitheater-style stage. (Courtesy Seattle Public Library, spl_wl_sec_00360.)

BAND SHELL. People perform whirls and twirls of Scandinavian dance at the International Mall at the World's Fair. A hyperbolic paraboloid shell acts as both the stage and exhibit for attendees of the fair. (Courtesy Seattle Public Library, spl_wl_exp_00626.)

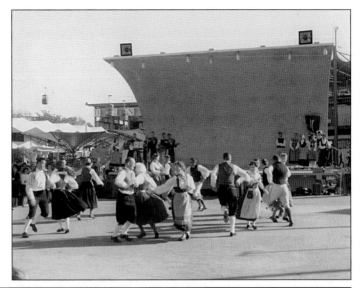

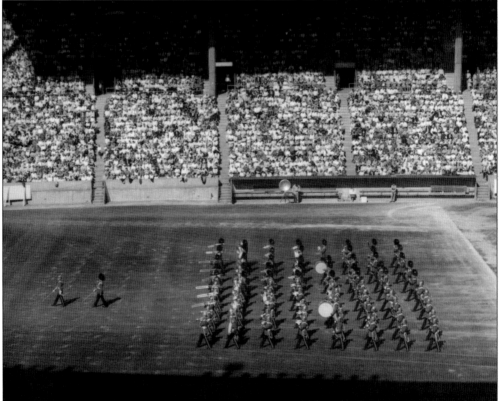

MEMORIAL STADIUM. This large venue, located at the Seattle Center, was built in 1948 in memory of Seattle high school students who lost their lives in World War II. The 1962 World's Fair opening ceremonies were held here. It continues to be a popular place for showcasing band performances during outdoor festivals such as Bumbershoot. Pictured here is the Canadian Tattoo, a Canadian military performance that left spectators in awe with a dramatic retelling of Canadian history. (Courtesy Seattle Public Library, spl_wl_exp_00907.)

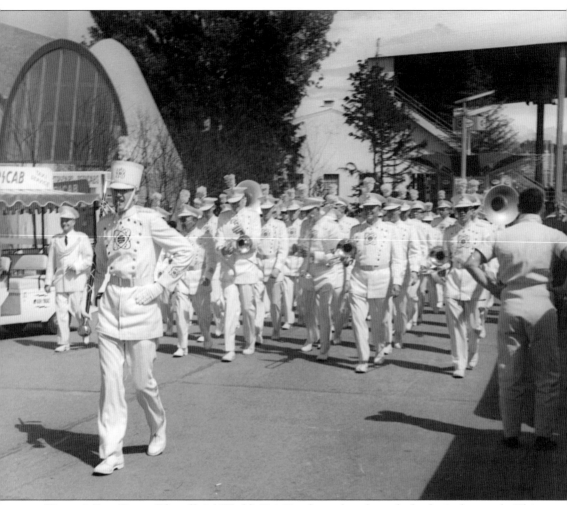

WORLD'S FAIR BAND. The official World's Fair Band marches through the festival grounds. This band, as well as the fair's official songstress, Paula Bane, performed patriotic songs for the fair's closing ceremonies in October 1962. Memorial Stadium can be seen in the background. (Courtesy Seattle Public Library, spl_wl_exp_00091.)

Seven

THE STREETS ARE ALIVE WITH MUSIC

Despite Seattle's famous rainy weather, the area has been a popular location for outdoor music venues and attractions. For instance, simply walking down Seattle's streets today, visitors and locals do not find it uncommon to pass several different musicians sharing their sound with a passing crowd. Be it a band performing Andean music, a barbershop quartet, or a piano player who has built wheels into the legs of his lovely musical instrument, street performances provide a unique, interactive environment for both artist and listener.

Performing on city streets was not always lawful though. As early as the 1970s, it was illegal to play a guitar on the city sidewalk unless the musician was blind or disabled. Musician Jim Page became accurately aware of this law when a police officer informed him that as a performer in perfectly fine health he had to cease playing his guitar on First Avenue. With a little community and press help, in a short period of time Page, with a guitar in hand, presented a testimony against this law before the city council. The law was reversed on that day in 1974. Nearly 40 years later, Jim Page continues to be an active and influential member of Seattle's music world.

LESCHI PARK DANCE PAVILION. This 1929 photograph of Leschi Park and its pavilion depicts the lush and tranquil scenery, perfect for picnics and musical entertainment. It is a far cry from the six-story casino that once stood at this location. The waltz and two-step were popular choices for the 1,200 people who would dance here for such events as charity balls and anniversaries. (Courtesy Seattle Municipal Archives, 29634.)

GREEK THEATRE. A well-equipped orchestra sits in front of columns at the University of Washington. A wide range of outdoor performances in city parks and community venues have been and continue to be successful activities for both musicians and their Seattle-area audiences. (Courtesy Washington State Archives, AR-07809001-ph005175.)

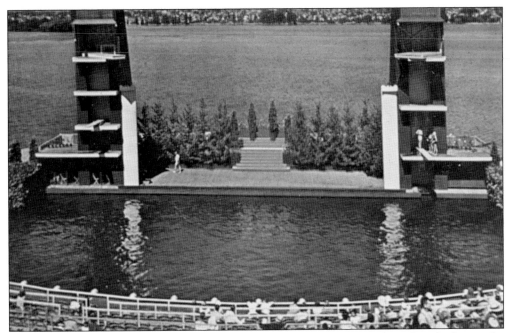

AQUA THEATER STAGE. Perhaps one of the most popular outdoor venues in Seattle during the mid-20th century, the Aqua Theater on Greenlake (not to be confused with the Aqua Barn on Lake Union) was open from 1950 until the late 1960s. This venue hosted water ballet, comedy, Broadway performances, song, and diving exhibitions. (Author's collection.)

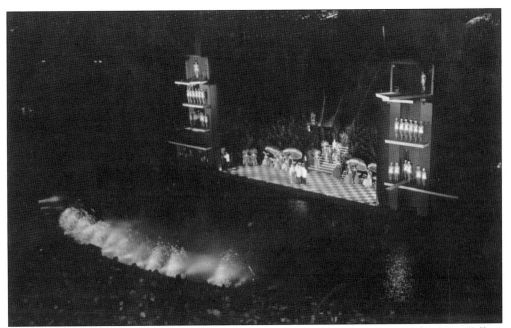

AQUA THEATER IN PERFORMANCE. Pictured here is an evening performance of the Aqua Follies. The Aqua Theater was built in 67 days and cost approximately $247,000, seating a total of 5,582 people by the 1960s. Tickets averaged from $2 to $3.50. (Author's collection.)

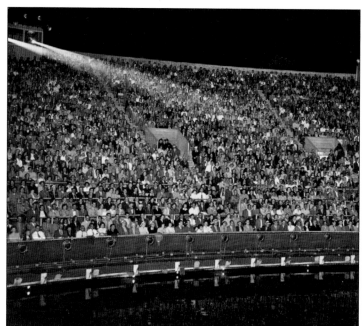

AQUA THEATER AUDIENCE. Calm waters reflect for a crowded scene in this photograph of an evening gathering at the Aqua. This venue was one of the opening attractions of Seafair, Seattle's maritime festival, and it was a sold-out debut. (Photograph by Forde Photographers, courtesy Seattle Municipal Archives, 65321.)

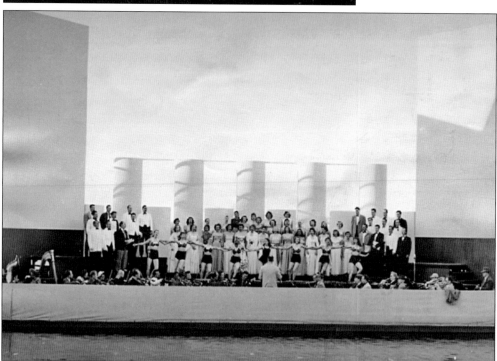

AQUA THEATER REHEARSAL. Pictured here is a 1950s dress rehearsal for Music under the Stars. Although performances such as *Kiss Me, Kate* received rave reviews, Music under the Stars productions were occasionally box-office disappointments, and not only because of the Seattle's familiar wet weather. With theories ranging from not enough famous names in the shows to financial cuts by the parks department, the Aqua Theater experienced serious struggles through waves of success. (Courtesy Seattle Municipal Archives, 65317.)

EMALEE EARON. This is Aqua Theater performer Emalee Earon. Other performers who passed through this venue's watery walls were Jean Gray, Charles Sherwood, Walter Snellenberg, Sara Dillon, Boris Mishel, and Pamela Britton, just to name a few. (Photograph by Bruno of Hollywood, New York City, courtesy Seattle Municipal Archives, 31251.)

BETH HAWKINS. In this photograph, Beth Hawkins (left) entertains with her famous soprano, and sometimes contralto, voice. A highlight at Cornish College of the Arts performances, Hawkins also performed at the Aqua Theater several times, including once in July 1952 with David Herald in a production of *South Pacific*. (Courtesy Seattle Municipal Archives, 31243.)

GUSTAVE STERN. This is a 1950s photograph of Gustave Stern, musical director of the Seattle Parks Department, who helped oversee many Aqua Theater musical productions. He was born in 1901 in Duisburg, Germany, and began his musical training at the age of three, playing piano by five years old and eventually training as a conductor at the Leipzig Conservatory. (Courtesy Seattle Municipal Archives, 29957.)

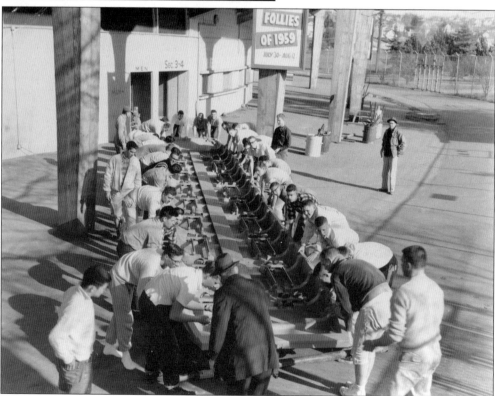

AQUA FOLLIES. Employees are setting up for a new season of Aqua Theater in 1959. The Aqua Follies performances ended in 1964, and the venue was later used mostly for local productions. The Grateful Dead performed here in 1969, and that was one of the last events to be held there on the lake. (Courtesy Seattle Municipal Archives, 29215.)

AQUA FUN AND GAMES. In a July 1952 production at the Aqua Theater, 12 performers from Scotland, as well as Scottish descendants, participated in the Music under the Stars production of *Brigadoon*. The three-night performance was choreographed by Marguerite De Anguera, and the stage director was Ralph Rosinbum. (Courtesy Seattle Municipal Archives, 31246.)

ENTERTAINMENT AND RECREATION. In this humorous photograph is Ben Evans (third from left), director of recreation from 1917 to 1960, and Hans Thompson (fourth from left), superintendent of parks and recreation from 1969 to 1973. Seattle city parks have played and continue to play a significant role in bringing music, art, and performances to Seattle citizens. (Courtesy Seattle Municipal Archives, 31382.)

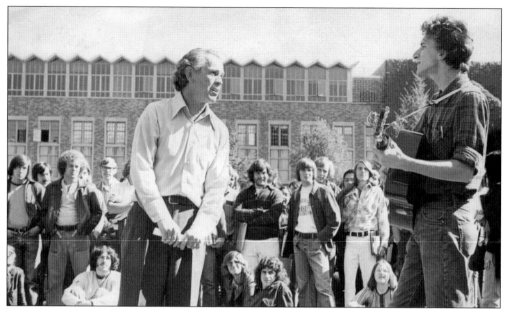

Jim Page and Holy Hubert. Performing on the grounds of the University of Washington around 1972 are Jim Page (right) and "Holy Hubert" Lindsay, the "Grandfather of the Campus Preachers." In what was an intensely political, creative, and interactive debate, yet unintentional and spontaneous, between a campus preacher and musician, the two performed together and earned a two-page spread on the campus paper the following day. (Photograph by Shawn Crowley, courtesy Jim Page.)

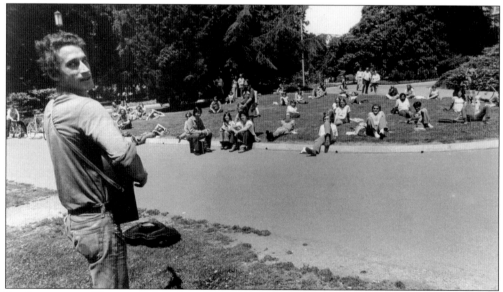

Jim Page at the University of Washington. Here is Jim Page performing on the University of Washington campus. During the summer break period, Page could be seen beginning his musical travels around noon in the University District neighborhood. Later, in the afternoon, he would perform in coffeehouses and lounges offering happy hour. By evening, he was sharing stories and song to late-night patrons coming from bars and clubs. Some days, he would perform throughout Seattle from 11:00 a.m. until 1:30 a.m. (Courtesy Jim Page.)

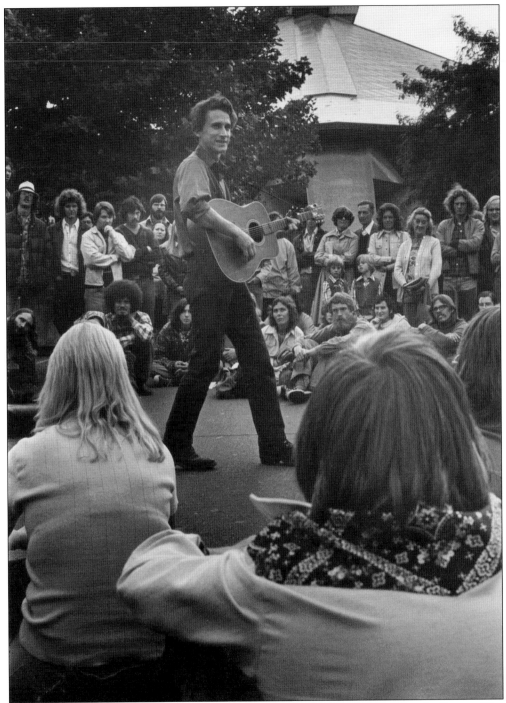

Jim Page at the Center. Pictured here is Jim Page performing in the Seattle Center. The Washington State Coliseum, later known as Key Arena, can be seen in the background. Page arrived in Seattle in the early 1970s. At the time, a band or musician would often perform at a venue from 9:30 p.m. to 1:30 a.m. several days a week versus several different musical acts performing on one stage for one night only, as is common today. (Photograph by Foy Page, courtesy Jim Page.)

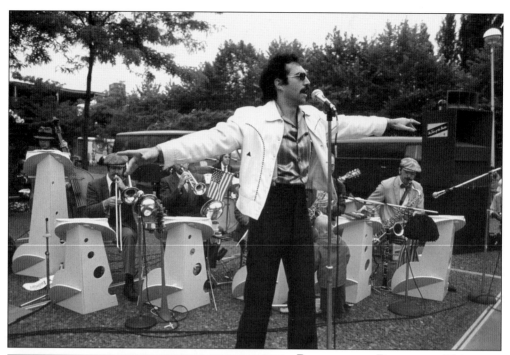

BUMBERSHOOT PERFORMER. This is a 1974 photograph of one of the many musical performers at Seattle's famous Bumbershoot festival. The first Bumbershoot was held in Seattle in 1971 and called Festival '71. It was a two-day event, showcasing indoor motorcycle races, horseback rides, and musical acts that drew an estimated 150,000 people. (Courtesy Seattle Municipal Archives, 77474.)

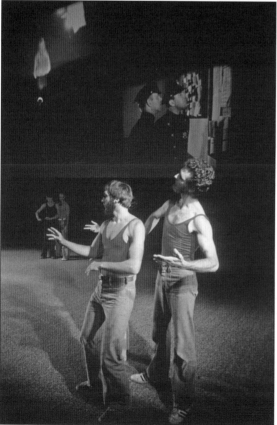

BUMBERSHOOT SONG AND VIDEO. Although many activities demonstrated at Bumbershoot are held outdoor, some musical events take place indoors. Performing here are two artists integrating song, dance, and video in 1973, the first year this festival was referred to as Bumbershoot and held for a period of five days. (Courtesy Seattle Municipal Archives, 77447.)

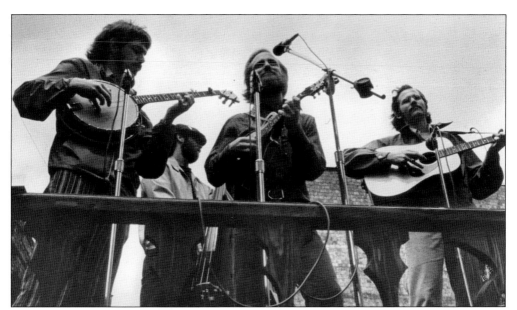

PIKE PLACE MARKET PERFORMERS. Seattle's Pike Place Market is arguably one of the most famous venues for Seattle music. Pictured here is a band performing on a flatbed truck for the Pike Place Market's 65th anniversary in 1972. To this day, patrons can listen to comedy as well as piano, drums, and all types of live music from around the world by simply strolling the market stalls. (Courtesy Seattle Municipal Archives, 33096.)

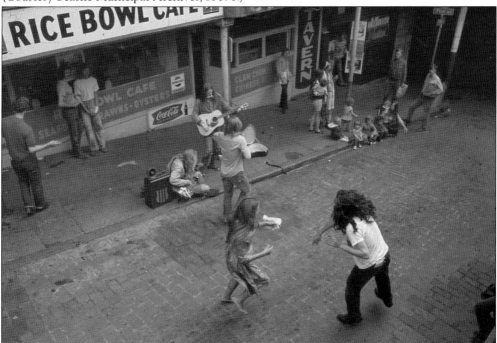

PIKE PLACE MARKET DANCERS. Music and dance fill the underground nooks and crannies of the Pike Place Market in this 1972 photograph. Pictured in the right background is the Victrola Tavern, a popular place for music, art, and poetry during this era. (Courtesy Seattle Municipal Archives, 34968.)

PIKE PLACE ART. Here is a piece of artwork displayed at the Pike Place Market. It creatively demonstrates a perspective of Seattle and its residents in the 1970s, especially surrounding the market. (Courtesy Seattle Municipal Archives, 32106.)

PIKE PLACE MARKET BAND. A full band performs on the cobblestone street of the Pike Place Market in the mid-1970s just outside what appears to be the Victrola Tavern. Tavern owner Jim Butler was also a Pike Place Market resident when he was appointed to the Pike Place Market Historical Commission in 1973. (Courtesy Seattle Municipal Archives, 35942.)

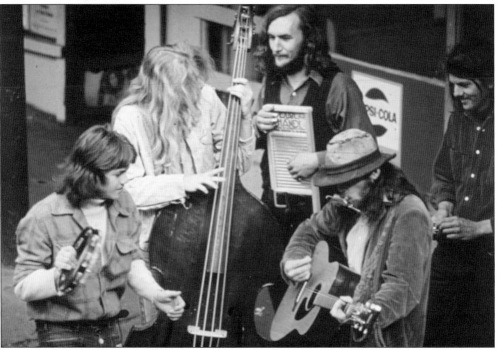

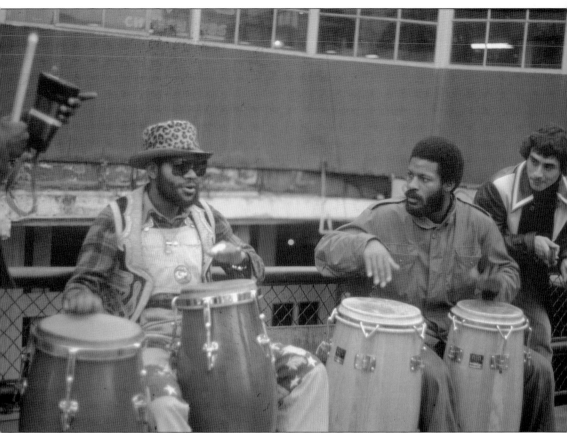

PIKE PLACE MARKET DRUMMERS, 1975. Percussion performers entertain crowds at the Pike Place Market. Conga drums and what appears to be a cowbell are played in unison just outside the entrance to the market. (Courtesy Seattle Municipal Archives, 35994.)

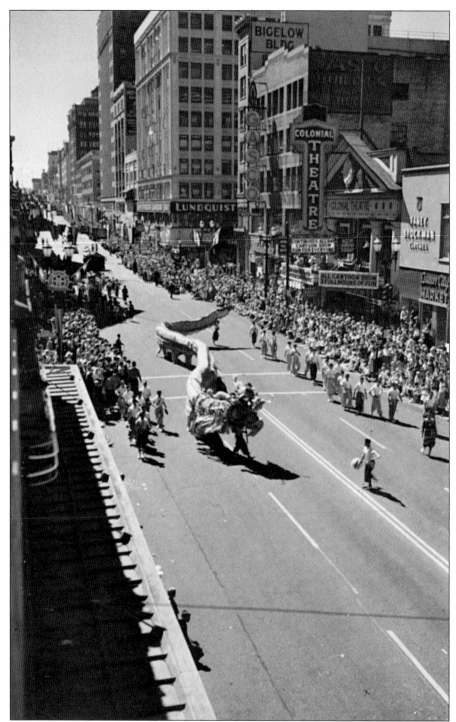

SEAFAIR PARADE. A Chinese dragon is being accompanied by drummers marching down Fourth Avenue during Seattle's Seafair festival. It started as the Golden Potlatch festival in 1911, and since then this weekend performance has filled the streets of Seattle with parades, music, visitors, and all levels of entertainment. (Author's collection.)

Eight

THE MANY FACES
OF THE FOX

The highly anticipated and very expensive Fox Theatre opened in 1929 to awestruck crowds. Designed in what some called the Spanish Renaissance, or Spanish Baroque, style by Sherwood D. Ford, this venue was the last of its kind to be built in Seattle.

The Fox has known many names and been under many different management groups or tenants, even before it was built. From 1926 to 1928, the future structure was referenced by owner Washington Theatre Enterprises as the Mayflower Theatre. It was only known as the Fox for a short period, from 1929 to 1932, by the Washington State Theatres. Jensen and Von Herberg changed to the name to the Roxy from 1933 to 1934. From 1934 to 1956, Cascade Theatres Corporation and John Hamrick Theatres, Inc. called the venue John Hamrick's Music Hall. The name was shorted to one of its most memorable, Music Hall Theatre, from 1956 to 1965 by the Olympic Incorporated and Edris Company. Sterling Theatres Company changed the name once again to the Seventh Avenue Theatre from 1967 to 1977, and the N&M Enterprises, Inc. changed it to Jack McGovern's Music Hall from 1977 to 1983. Under management of Evergreen Entertainment, Inc., the venue was once again called the Music Hall Theatre from 1983 to 1984. The last business venture, under My Emerald, Inc., was known as the Emerald Palace from 1987 to 1988. Despite extensive and heartbreaking efforts by the community, this building was razed in 1991 and 1992.

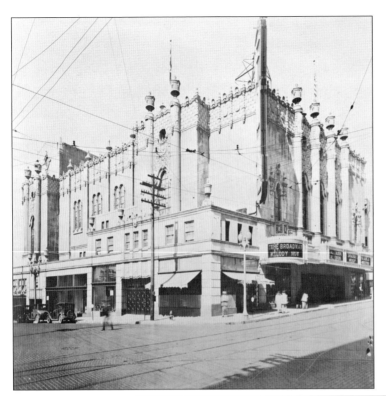

A Fox Introduction. Although primarily built for showing movies, the Fox Theatre had 30 dressing rooms and a prepared backstage always available for traveling shows. In April 1929, the Fox, which was originally going to be named the Mayflower Theatre, opened its doors to nearly 15,000 excited people waiting to see the latest attraction, *The Broadway Melody*, in the latest grand venue. Tickets cost between 35¢ and 60¢. (Courtesy Library of Congress, 040772.)

Mezzanine Lounge. This was the lush and exotic waiting era for a theater built for the golden age of cinema. The interior was originally decorated in 16th-century Spanish style. Note the high backs of the chairs and the intricate detail work on the ceiling. (Courtesy Library of Congress, 040774.)

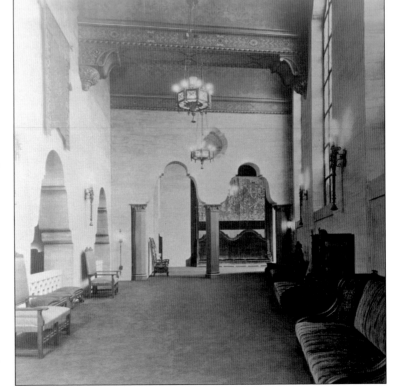

FOYER. Patrons entered the theater through timbered doors into this elegant foyer. The entrance was originally decorated with sumptuous red-carpeted stairs, a soft light, and walls that appeared like weathered stone. Note the suit of armor flanking the left side of the staircase. (Courtesy Library of Congress, 040773.)

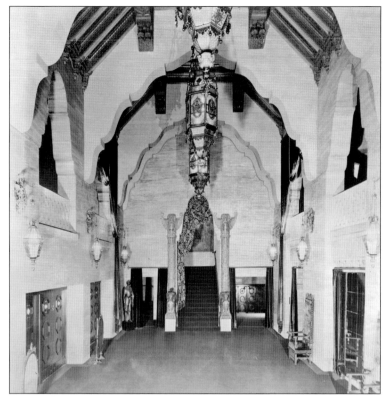

PROJECTION ROOM. A state-of-the-art projection booth provided projectionists with a warning system to change film when needed. Particular detail was paid to the lighting instruments, as these items played an important atmospheric role before and after a production for the orchestra and patrons alike. (Courtesy Library of Congress, 040777.)

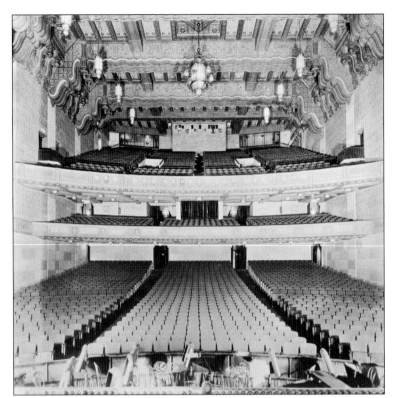

EARLY SEATING. This 1929 photograph of the Fox Theatre auditorium was taken from the stage. An electronic seating board gave the manager the ability to quickly locate empty seats. Note the orchestra pit, as well as the elaborate light fixtures and ceiling detail. (Courtesy Library of Congress, 040775.)

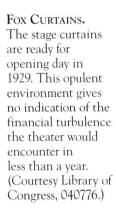

FOX CURTAINS. The stage curtains are ready for opening day in 1929. This opulent environment gives no indication of the financial turbulence the theater would encounter in less than a year. (Courtesy Library of Congress, 040776.)

A View from the Air. Here is a 1991 view of the Fox Theatre (center), then known as the Emerald Palace, from the Camlin Hotel. The venue almost appears swallowed by the growing number of skyscrapers and crowding streets. (Courtesy Library of Congress, 040727.)

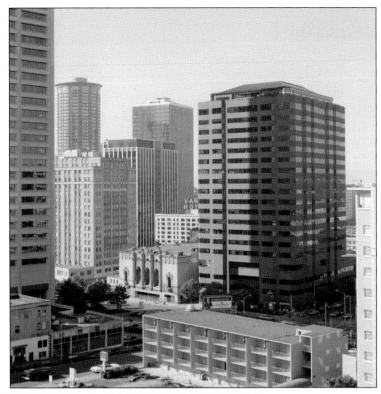

Welcome to the Fox. This is a view of one of the theater's entrances from Olive Way. Note the sharp contrast of the window frames of the theater compared to the windows of the skyscraper to the right. The original vertical neon Art Deco "Fox" marquee was located at the southwest corner of Seventh Avenue and Olive Way (left corner) and extended over the canopy. (Courtesy Library of Congress, 040728.)

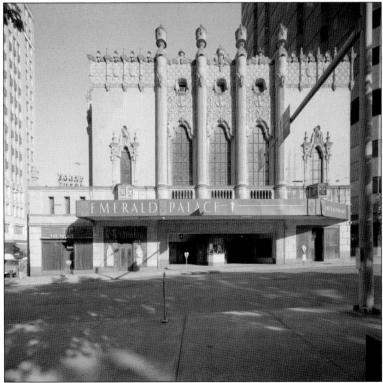

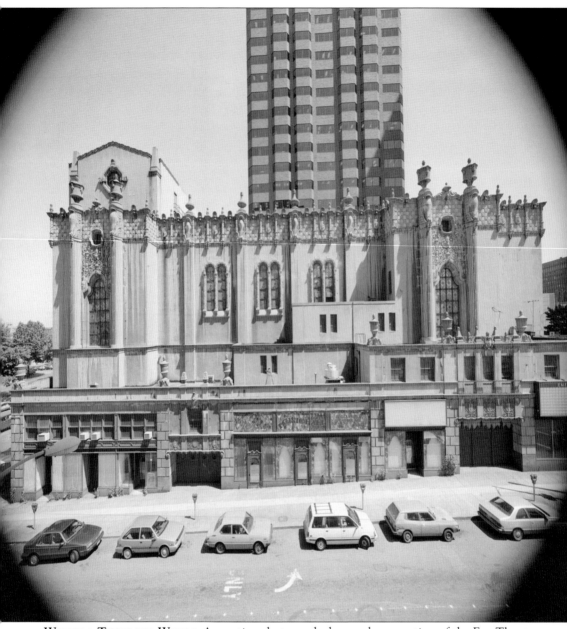

WORTH A THOUSAND WORDS. A creative photograph shows a large portion of the Fox Theatre from Seventh Avenue. Storefronts in the building, some pictured here, were defined by rusticated cast stone with a recessed marble threshold. It was known as the Mayflower in property documents up until the 1940s; however, despite business inside and out of this venue, by as early as 1931 property taxes for the land on which the theater sat were in default, and the financial security of the building's future was near collapse. (Courtesy Library of Congress, 040730.)

OF BUT A MEMORY. Time and the elements have taken a toll on the structure, as can be seen on the outside walls and corners of this early 1990s image. In 1932, the theater was auctioned off at a sheriff's sale. Charles F. Clise made the winning bid and received a quitclaim deed before the year was out. (Courtesy Library of Congress, 040731.)

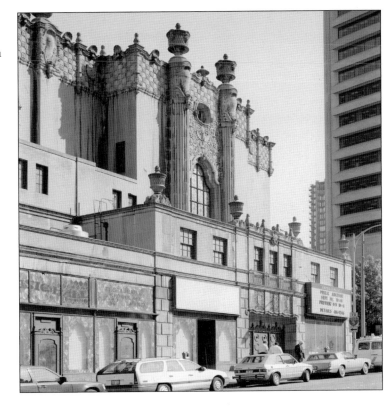

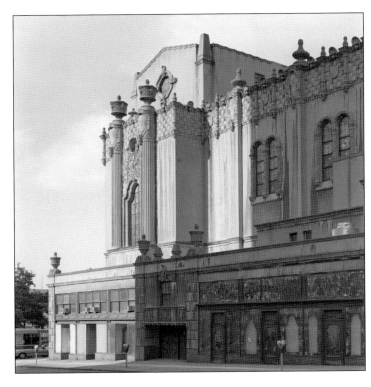

LANDMARK IN THE SHADOWS. The weatherworn theater sits partially in the shade of a neighboring skyscraper. By 1944, company ownership of the theater, the Mayflower Building Company, merged with the Marcus Whitman Hotel Company in order to continue operations. In 1950, the merged operations split, and management of the theater went to the next in a long line of management teams to come. (Courtesy Library of Congress, 040732.)

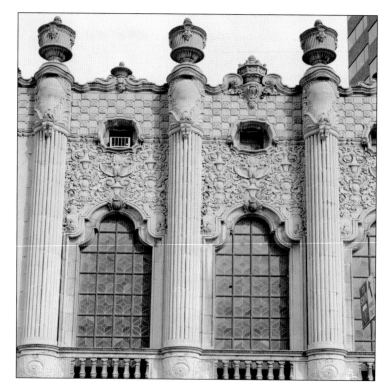

COLUMNS AND CARVINGS. Here is the ornate sculpted work that surrounded the windows of the theater facade. Pacific Stone Company provided all the cast stone for the structure. The exterior was dubbed in a *Seattle Post-Intelligencer* article as "Spanish Plateresque." (Courtesy Library of Congress, 040735.)

OUTDOOR SCULPTURES. Pictured is one of the stone urns that decorated the pillars and rooftop of the theater. This particular urn could be seen from Olive Way. Note the stonework deterioration. (Courtesy Library of Congress, 040736.)

EMERALD PLACE ENTRANCE. A close-up view of the venue's vestibule shows the Emerald Palace's business logo, the theater's last attempt to revive activity in the building. The glass ticket-booth windows can be seen in the center. (Courtesy Library of Congress, 040737.)

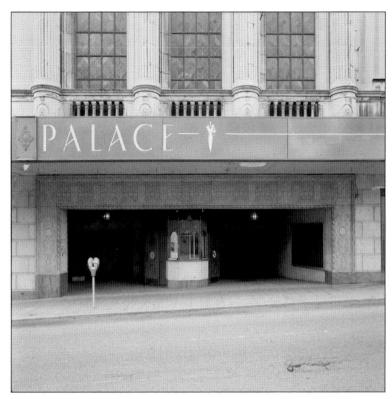

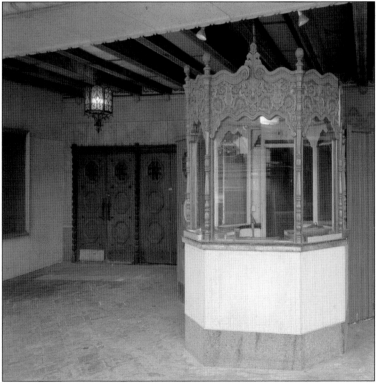

THE TICKET BOOTH. This image of the entrance details the artistry of the ticket-booth trim. The area originally had patterned tile flooring with stucco walls and display cases that were in cast stone. Note the elegant entrance light near the doorway to the left. (Courtesy Library of Congress, 040738.)

An Ornate Doorway. The imprint of ornamental wooden griffins can be seen above the door frames in this photograph. The griffins were stolen in 1991 shortly after protective barriers were removed from the door frames while the building was being prepared for demolition. (Courtesy Library of Congress, 040739.)

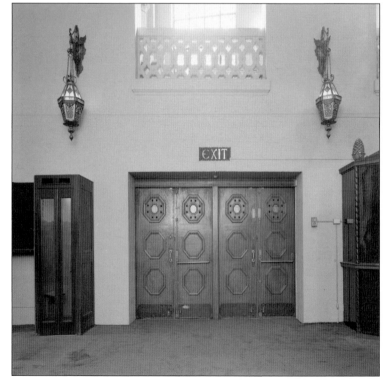

An Ornate Entrance. An imposing doorway and wood phone booth welcomes visitors inside the theater. Over its 60-year existence, little alterations were made to the theater structure, although quite a few were made to the interior. At the time the theater opened, there was no refreshment stand, and coat checks were located elsewhere. Note the international welcoming sign of the pineapple on the right. (Courtesy Library of Congress, 040740.)

DETAILED STAIRWELL.
This is an aerial image of one of the public spaces in the theater, which was once covered in ozite carpeting, images of Spanish galleons, and heavily textured walls. During the second Music Hall era, the interior was decorated with upholstery of red, gold, and purple. (Courtesy Library of Congress, 040742.)

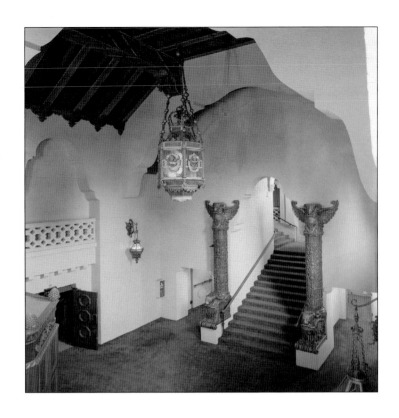

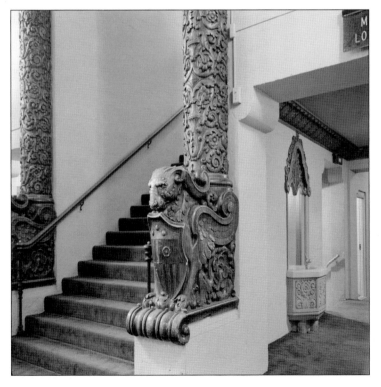

FOX STAIRWELL.
Flying rams on each side of the stairwell welcome patrons to the grandiose establishment. A portion of the "Men's Lounge" sign can be seen in the upper right. Some comforts patrons once found in this venue were finely upholstered Spanish-styled chairs, silver ashtray stands, and tapestries. Note the open doorway in the background, which led visitors to the storefronts on Seventh Avenue. (Courtesy Library of Congress, 040743).

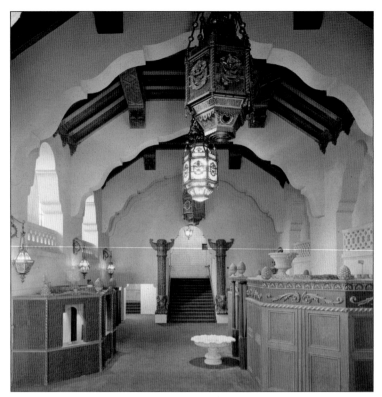

A Plush Waiting Area. Alterations were made to the theater in the 1970s to provide room for banquets and dinner tables. Some areas were sectioned off to provide room for an open arcade and bar. Note the many welcoming pineapples that still decorated this well-lit section of the venue. (Courtesy Library of Congress, 040741.)

A Detailed Painting. Pictured here is a detail of some wallpaper on the east side of the stairs at the first landing from the foyer. Shortly before the photograph was taken, this particular image was hidden behind a false wall that was constructed during one of the building's alterations. Later, a mirrored image of a galleon was found on the opposite (west) side of the stairs. (Courtesy Library of Congress, 040745.)

SHADOWED HALLWAY.
This is a haunting
image of the upper
lobby. These areas
originally housed
small coat-check
rooms. Note the oculus
in the foreground
(upper center).
(Courtesy Library of
Congress, 040746.)

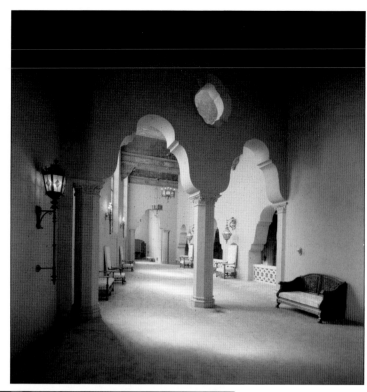

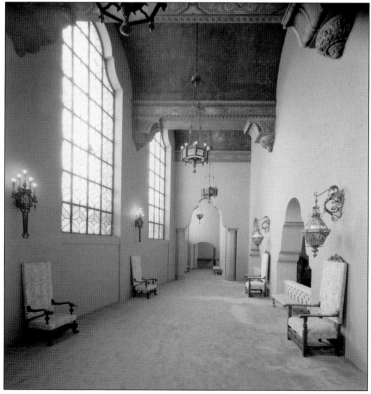

SUNLIT HALLWAY.
Here is another
photograph of the
mezzanine lounge.
The almost-Gothic
appearance is brightly
lit through amber-
colored windows.
The colored glass
was made possible
by translucent
glazing composed
of lightweight mica.
Note the arched
hallway ceilings
and candelabras.
(Courtesy Library of
Congress, 040747.)

Light Fixture. The theater's original electrical engineers were with the Ne Page McKenny Company. By the 1970s, a new spider lighting system was installed in the auditorium, replacing several original fixtures, while other fixtures were replaced with plaster basket house lights. (Courtesy Library of Congress, 040744.)

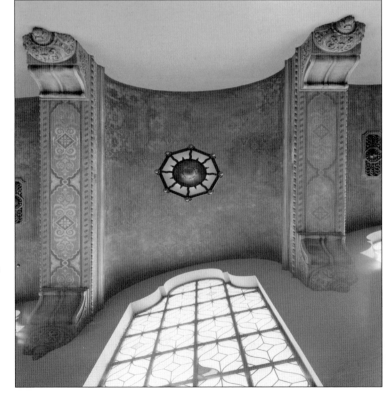

Looking Up. Looking directly up from the floor in the mezzanine lounge, this photograph details one of the many lanterns that dazzled both patrons of this venue. Original octagonal lanterns were made out of a combination of cast aluminum, stamped steel, and stamped brass. (Courtesy Library of Congress, 040748.)

THE LADIES' LOUNGE. Pictured here is a landing directly outside one of the ladies' restrooms. The stairs led to the mezzanine lounge, while the hallway on the right led to the theater's offices. The original ladies' restroom suite consisted of a lounge, restroom, and dressing room that contained Art Deco dressing tables and polka-dot upholstered chairs. (Courtesy Library of Congress, 040749.)

STAIRWELLS. The ominous stairs on the left lead to the west side of the theater balcony. Partitions were installed in 1966 to close the upper balcony from public use. Note the decorative space to the right that once was a recessed drinking fountain. (Courtesy Library of Congress, 040750.)

115

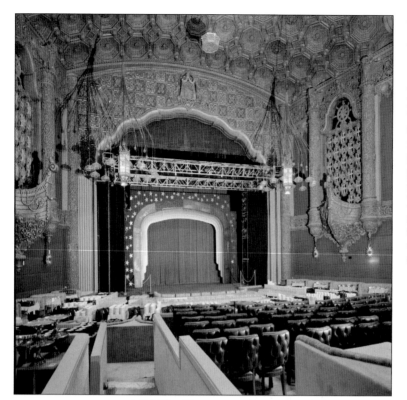

READY FOR AUCTION. This is a west view of the theater auditorium. At the time the photograph was taken, the seating arrangement was in preparation for the upcoming pubic auction of the theater's items. Note the elegant galleons on each side of the theater. (Courtesy Library of Congress, 040752.)

A VIEW FROM THE BALCONY. A large chandelier lights up the Fox Theatre from the perspective of a tier in the auditorium. At the apex of each arch in the theater was a ship's wheel. Between each beam in the upper walls, decorative seashells were illuminated by cove lighting. (Courtesy Library of Congress. 040753.)

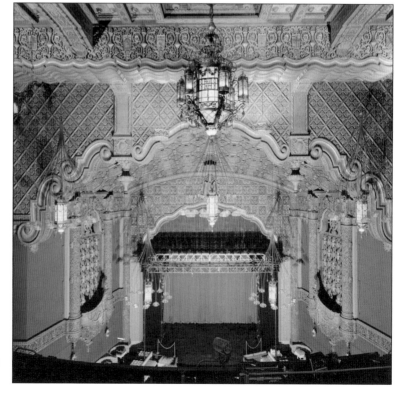

Fox Seating. This is a view of the auditorium from the stage area. Four levels of seating have replaced the initial three-tiered seating. Originally, the orchestra level of the theater was built out of encased concrete. By 1989, the auditorium measured 102 feet from front to back and 92 feet from side to side. (Courtesy Library of Congress, 040754.)

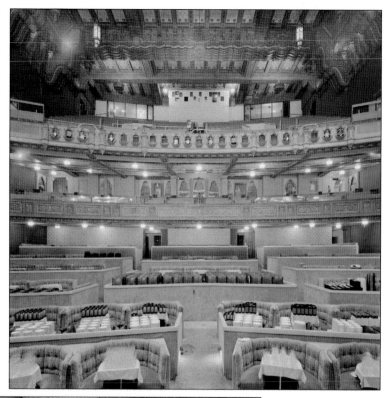

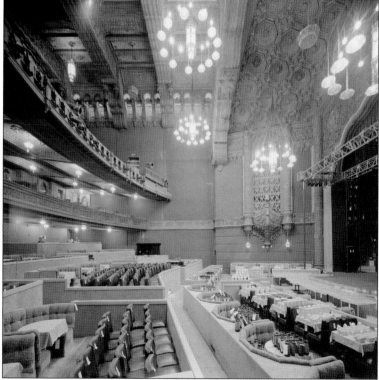

First-floor Seating. A detailed photograph depicts the different tiers of seating in the theater auditorium. This area was painted in a rich brown color with highlights of red, teal, blue, and taupe. Lighting was used to simulate the image of aged wood. (Courtesy Library of Congress, 040755.)

117

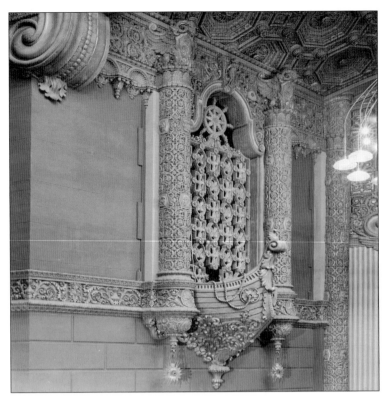

BOAT EMBELLISHMENT. Seen here is detail of a one of the two imposing and ornate Spanish galleons in the theater's auditorium. They were painted in colors of bright orange, red, and black on paper-backed gold foil. (Courtesy Library of Congress, 040757.)

SUN EMBELLISHMENT. This image shows a sunburst lamp close-up in the auditorium. It is one of the four ornamental sunburst motifs that hung on each side of the galleons near the theater organ grills. (Courtesy Library of Congress, 040758.)

Light and Exit. This is a detail of a light fixture near an exit from the floor auditorium. Several of lights like these were located on the ceilings of the mezzanine lounge. (Courtesy Library of Congress, 040759.)

Wall and Lamp Embellishment. Here is a frosted-glass and foliate-pattered chandelier, one of many under the mezzanine and balcony. This one in particular was located on the east side of the balcony. Some chandeliers in the auditorium that once hung over the orchestra pit could be raised or lowered to light the establishment as necessary. (Courtesy Library of Congress, 040764.)

CEILING DETAIL. Pictured is the ceiling in the auditorium near one of the galleons. The ceilings were made of suspended plaster and covered in a soundproof layer of Celotex, plaster, and finally paint. (Courtesy Library of Congress, 040756.)

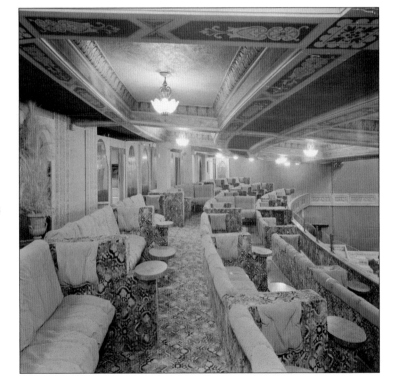

SECOND-FLOOR SEATING. This is a view of mezzanine seating in the auditorium, reflecting one of most recent changes made to the venue: Las Vegas–style carpets. In the 1970s, nearly $1.4 million worth of auditorium alterations was invested to transform the venue into a performance and dinner hub. Of all the alterations made to the venue, changes made during this time were the most extensive. (Courtesy Library of Congress, 040751.)

SECOND-TIER SEATING. Here is a balcony view of the Fox Theatre auditorium. During the revisions to the interior in the 1970s, to prepare for the last establishment—the Emerald Palace—many of the common areas were painted mint green, and mint-green carpet was placed in the foyer. (Courtesy Library of Congress, 040761.)

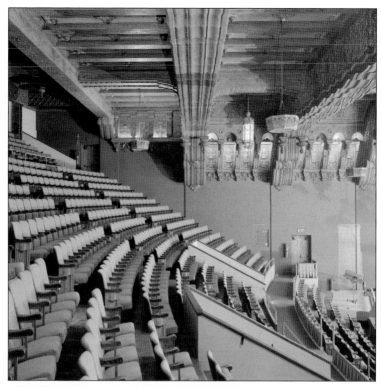

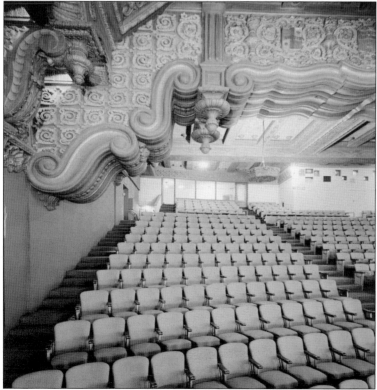

FIRST-TIER SEATING. Pictured from a ladder is the east side of the balcony. In the background are the "crying room" and the projection booth. The crying room, built specifically for mothers of very young or fussy children, was a highlight at the time the theater opened. Another specialty room built in a similar fashion was made for men who preferred to smoke during a show. (Courtesy Library of Congress, 040762.)

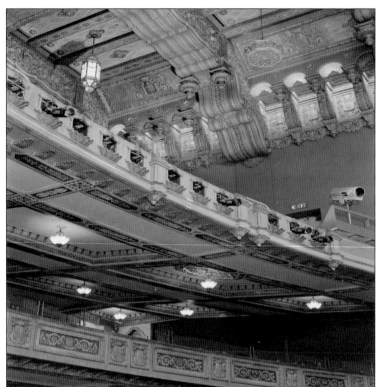

VIEW OF THE SECOND TIER. Looking up from the auditorium floor provides a breathtaking view of the auditorium balconies and ceilings. Most of the plasterwork was sculpted in a low or deep relief and, when finished, resembled handcrafted woodwork. Note beams that were supported by consoles. (Courtesy Library of Congress, 040760.)

WALL DETAIL. Pictured is a detail of the west wall balcony. Stenciled soffits like these were located throughout the building. (Courtesy Library of Congress, 040763.)

FINE DETAILS IN FIXTURES. Pictured is a close-up of the main chandelier located above the balcony. Several chandeliers were made of amber-toned mica in the shape and appearance of brown and orange diamonds that provided a leaded-glass appearance. (Courtesy Library of Congress, 040765.)

DRESSING ROOM. Seen here is the basement corridor of the Fox Theatre dressing rooms located on the west side of the building. An identical corridor also ran along the east side of the theater. The displayed seats in the corridor were once a part of the Orpheum Theatre. (Courtesy Library of Congress, 040769.)

THE MEN'S LOUNGE. This is the basement lounge, located in the southwest corner of the building. The men's lounge is on the left, and the stairs lead to the foyer near Seventh Avenue. Originally, this men's room included arched and oval mirrors, more Spanish-style chairs, upholstered sofas, draperies, and leather chairs to accompany the ceramic and silver ashtrays. (Courtesy Library of Congress, 040770.)

THE STAGE. A counterbalance system, which was used for lifting curtains, was located behind the stage of the theater. This system was enhanced in the 1960s as the theater was preparing for more touring live performances. The theater's original pipe organ was removed by 1964. (Courtesy Library of Congress, 040767.)

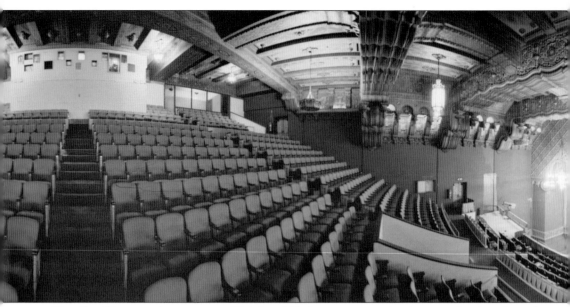

THE FOX THEATRE AUDITORIUM. This is a 360-degree panoramic photograph taken from the balcony by a Hulcherama camera with a 35-milimeter Mamiya Sekor lens. The image was captured

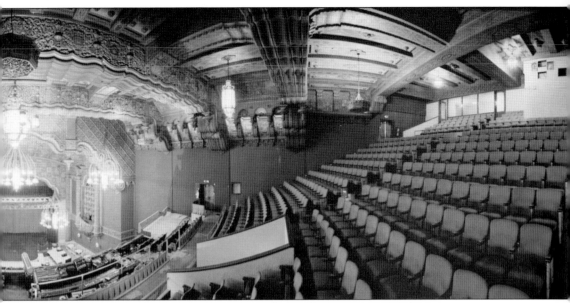

by Will Landon and John Stamets. (Courtesy Library of Congress, 040771.)

BACKSTAGE. Here is the beautiful backstage of the Fox Theater. Many live performances from touring musicals to local acts graced this stage, including Seattle's Civic Opera, performances by Bob Hope and Jeanette McDonald, Max Reinhardt's *A Midsummer Night's Dream* with Mickey Rooney and Billy Barty, and in 1942 the Seattle Symphony's *The Nutcracker.* (Courtesy Library of Congress, 040766.)

DISCOVER THOUSANDS OF LOCAL HISTORY BOOKS FEATURING MILLIONS OF VINTAGE IMAGES

Arcadia Publishing, the leading local history publisher in the United States, is committed to making history accessible and meaningful through publishing books that celebrate and preserve the heritage of America's people and places.

Find more books like this at
www.arcadiapublishing.com

Search for your hometown history, your old stomping grounds, and even your favorite sports team.